Back Words

one painter's voice in the conversation

Peter Malone

Copyright © 2012 Peter Malone

All rights reserved.

ISBN-10: 1478182210
ISBN-13: 978-1478182214

For Melville and John,
who unlike their old man were
always good students

CONTENTS

	Introduction	1
One	childhood, music and my first taste of college	12
Two	entering art school	33
Three	student or artist?	49
Four	bricks	62
Five	a reluctant graduate student	72
Six	artists and students	93
Seven	artists and the university	105
Eight	artists and the exhibition space	118
	Epilogue	135
	Bibliography	146

ACKNOWLEDGMENTS

No one produces a book on their own. I could never have realized even this modest volume without the assistance of my wife Susan, who as a librarian and lifelong reader helped me put its many disjointed ideas into coherent form; nor would I have recognized the need to brush the academic cobwebs from my sentences were it not for Philip Wagner's editorial lucidity. Brian Hack generously copy-edited the manuscript and offered many insightful suggestions, including several points of art historical nuance that helped gird my arguments.

I am deeply grateful to all.

Peter Malone
New York City, 2012

Introduction

"As civilized human beings, we are the inheritors, neither of an inquiry about ourselves and the world, nor of an accumulating body of information, but of a conversation, begun in the primeval forests and extended and made more articulate in the course of centuries. It is a conversation which goes on both in public and within each of ourselves."

Michael Oakeshott

Having completed a productive session devoted to a portrait of my father-in-law I begin my clean-up routine: rinsing brushes in turpentine, scrubbing them with soap and water and returning them to their standing positions in containers of varying sizes. The wet canvas is gently placed face-in against the others already leaning on the studio wall, the palette is scraped clean and the paint residue is discarded.

Two hundred years ago a version of this same clean-up routine would have begun with a polite dismissal of the sitter. Like many contemporary painters I often take photographs of my subjects to avoid those interminable sessions a sitter would otherwise endure. As a particularly slow painter I would need about thirty hours of sitting time, a schedule even a retiree is reluctant to accommodate. But aside from social niceties between painter and subject, the routine itself has probably remained unchanged since the eighteenth century. By

replacing the oil in the paint with beeswax a modified version of the same routine will transport you back to the first century and to the Coptic artists who painted likenesses for mummy cases.

But the history of art is much older than the Roman Empire. Cave paintings that date to 30,000 bce suggest that perhaps artists, rather than those usually identified, are the true practitioners of the world's oldest profession. Yet a transfer of this distinction is unlikely, as our modern usage of the word professional has become inseparable from the notion of compensation, and what distinguishes artists from their professional peers in contemporary society is their consistently poor income. With little hope of reaching the earning capacity routinely assured lawyers or dentists, artists rely on a more formal definition of the term professional, like the one found in Webster's dictionary that defines it first as a declaration of one's beliefs, and second as an activity of special training. Income is only mentioned third.

Though income disparity is a unique marker for artists, it is generally accepted that we are indeed professionals. There is no other way to describe us. You could try placing artists in the world's oldest vocation, but a vocation implies providential intervention. We may be an egotistical lot but most of us would shy away from that claim. Occupation is a good catch-all term, as it makes reference only to the facts of how one's days are spent. But referring to artists as members of the world's oldest occupation suggests full-time artistic activity, which is nearly impossible when half the week is devoted to earning a salary to make up for the poorly compensated time expended in the studio.

To complicate things further, another aspect of an artist's professional standing is evident in their relation to a subgroup of artists known as amateurs. Amateur painters are indeed artists, but make no effort toward a career, meaning they do not work toward promoting a public reputation. They paint for themselves, or as the actual Latin root *amator* implies, they paint only for the love of painting. This original meaning of the word has unfortunately, and in some cases unfairly,

evolved into a pejorative—as in amateurish or poorly done. The two do not necessarily go together.

Professional painters share the same enthusiasm for art with their amateur brethren, but spend a great deal of time and energy promoting and exhibiting their work before the public, leaving themselves open to public criticism as well as the benefit of public dialogue. Successful professional artists can demonstrate a lifetime of participation in exhibitions, reviews in major newspapers, sales of work, occasional commissions and other evidence of a local, national or even international reputation. And yet with such accolades the overwhelming majority of artists still need a supplementary income like a teaching position, a gainfully employed spouse, or in the best of circumstances, both.

The difficulty of making a living as an artist is not unrelated to the greater difficulty society exhibits in placing artists in the general scheme of things, a predicament for which artists themselves are partly to blame. Beginning in the Renaissance when painters and sculptors boldly asserted an elevated professional status (which at that time meant parity with philosophers and men of letters and had little to do with money) and evolving through the revolutionary art movements of the nineteenth-century, artists have cut themselves loose from official protection, only to become social orphans. Set free in the modern world of the servitude that once defined their ancient forbears, the profession of the contemporary artist has become increasingly susceptible to the whims and fashions of the art market. Those artists today who design the useful things around us—architects, graphic artists and industrial designers—continue in a kind of elevated servitude, for as professionals they are both respected and generously compensated. Even in ancient times when artists were often slaves the lives of goldsmiths and potters were considerably more comfortable than common laborers.

Financial insecurity is the clearest indication we have of a general social ambivalence toward artists, an ambivalence that is doubly

irritating to painters like me, because art itself does not suffer the same indifference. While society expresses little concern for painters, sculptors, installation and video artists, it is downright vociferous in its clamor for more art. Support for the arts is relatively healthy in developed nations, while support for artists remains tentative, particularly in the United States. New York City boasts of its role as a world class art center, but relegates young painters to repaying their art school loans by sharing rent with fellow artists in Bushwick, while the custodians of the Big Apple encourage the adornment of lofts in and around Manhattan with the luxurious accoutrements preferred by hedge-fund traders. Logic, or at least a modest application of reason, suggests these well-heeled loft dwellers constitute a potential market for artists seeking patrons for their work. But as already stated, commerce has about as much relevance to an artist's daily reality as it does with motivating an individual to become an artist, which begs the real question, why would anyone even consider such a profession?

Assuming that each artist has their own story, and that many of these stories are likely to share a few general characteristics, I have tried here to answer the question by offering my own experience in narrative form. I did so in lieu of a concise answer because I have no concise answer. I felt instead I could walk the reader through the many episodes that formed my thinking about art, and about being an artist, and in doing so answer a great many smaller questions, thereby providing the reader with the next best thing—a coherent pattern of thought. It begins with how I discovered I was an artist, and ends decades later when I become inspired to paint portraits at a time when the more fashionable sectors of the art world hold little interest in such pursuits. A narrative seemed the best format because my decision to paint portraits was only one of a chain of decisions, experiences and epiphanies that made up my professional development. The assembly of such a narrative will itself reflect the fact that because art is an open-ended and creative endeavor, artists are in a constant state of self-discovery.

To be an artist is to find your own way. Whether as a blessing or a curse I was born with abilities and interests in a bundle of cultural pursuits that only complicated finding my true path. To navigate I had to constantly refocus on the meaning of what I was doing. The freedom we associate with being an artist was in my case tempered by a sense of responsibility to provide viewers of my work with relevance. From the moment I recognized visual art as my cultural home, I have been searching for a subject matter that could match the thread of human feeling that had initially pulled me toward the life of an artist in the first place. It was never enough for me to mold my identity around an activity for which I had some facility. From the start I craved a greater purpose. Having arrived at the portrait I was rewarded with an approach to contemporary painting that I am confident will succeed or fail on the strength of my talent and industry alone. In other words, after years of searching I have come to realize an unshakable confidence in the portrait as a genuinely meaningful genre, even in an art environment created by a century of progressive, and at times manic experimentation. As a personal solution to the Post-Modern dilemma, I find portraiture gives my work a solid grounding in the one reality we human beings cannot ignore for too long—ourselves.

I came to this conclusion by way of a complicated and unorthodox educational process. Until I went back and examined my tracks I was not even sure myself how it happened. This book then is a look back at how I got to where I am today as a painter, and is based on the premise that there is little difference between being and becoming an artist. To review my motivations, I revisited the steps that made up my evolution, in the hope that I could resolve how in a passive sense I discovered my professional role, and in a proactive sense how I defined and redefined that role over a considerable period. I felt it was time to systematically investigate the intuitive process that brought me here—to put the artist I have become on the analyst's couch while I sit, pen and pad in hand, and examine the patient. As an instructor in the college classroom it has often fallen to me to explain

to members of the general population what artists do and why they do it. So for the reasons stated above, and to better serve my students, I thought a review of how I developed as an artist would provide the best response.

Once committed I knew it was not going to be easy, because an understanding of your own motivation can be just as elusive as trying to understand another's, perhaps more so. Distant memories are susceptible to distortion and mirage. As mental notes for this project were settling in my mind, I happened to be completing my winter vacation reading list, which included Richard Brookhiser's biography of James Madison. Barely three pages in, my concern for writing about myself and the dangers of over thinking connections made in retrospect, echoed in these words: "Madison would soon become interested in politics; we do not know if he made the connection, but herding small children is good training for certain aspects of legislative work." I was struck by the author's careful tone in this one short sentence, warning that caution is indispensable when addressing any subject's motives. Regardless of whether the subject is another or yourself, when declaring why someone acted as they did, the hazards are the same. Brookhiser's suggesting, rather than asserting, that Madison may have fallen under the spell of politics from having experienced the guiding role of eldest sibling, is an example of a writer's tactful caution in the face of evidence compressed by history into tempting correlations. Not only do we lack evidence, as he notes, that Madison thought his sibling's charge had been a precursor to his career, we can be reasonably certain the adolescent Madison was unlikely to have firmly arrived so early at a career choice. And if he was indeed attracted to public life at a very young age, it could not have been the only notion in his head. Youth is a time of confusing stimulation, and the consequences of following one's nature are better perceived, and commonly acted upon, beyond the age of twenty.

For many of us, merely finding our inclination takes years. And yet for some, hints do come early. For an artist like myself, and I

suppose for politicians and other unusually motivated people, the germ of our individual obsession is present in some form or another in our early years. And yet it is also true that there are those who choose an entirely different path than what an objective observer would have predicted based on talent or other youthful indicators. It's not difficult to conclude that any understanding of this meandering process is improved by hindsight—by looking backwards.

Though I could not have known it at the time, my career path began at age six, and continued through an endless revising and questioning of directions taken. Therefore, what you are about to read is a string of episodes that attempts to reconstruct my often contradictory thoughts regarding art, and what it meant to me at each stage. My dual focus was to review the process of becoming an artist, and to map as best I could the pathways taken in that pursuit. I chose myself as subject, not because I thought my experiences were extraordinary, but for the opposite reason, that my experiences are likely to reveal common aspects with other artists. It is my hope it will prove useful reading, not only for young and established artists, but for anyone interested in why artists persist in their efforts, when it seems inevitable that they will end up stitched to society's fringes.

Though aware of the dangers, I feel I can trust my own memories enough to reassemble them in a coherent order. Whether my analysis of those memories proves pertinent I'll leave to the reader. The focus of my attention will be on specific events that in retrospect seem significant. Though many artists find a general sense of direction early in their career, some of us discover it in disjointed increments, the proper sequence of which remains hidden until decades have passed. And if that is not as common as I think, I'll gladly retrench to the position that it was true for me. Because mine was an unusually lengthy development, it is my wish too that people whose lives have a strong sense of purpose will find this narrative familiar in form, if not specifically in content. In the end, all human experience is woven in

similar patterns. And yet, I am sure those involved in creative endeavors will find these pages especially amusing.

For clarity I have kept my focus on the narrow trail of my thoughts as they relate to art. All my life I've had a sturdy sense of the distinctly public character of those whose activities effect the cultural environment. And not just in relation to art but to all public action motivated by an individual's unique perspective, which is another reason why I was intrigued with Brookhiser's characterization of Madison's leaning from an early age toward a public role. Like a politician, an artist's relationship to the public aspect of their work is tethered to the essentially private source of their inspiration. Artists and politicians are similar too in that their respective professions require a nimble mobility between the private and the public. They share a similar responsibility toward bridging the gap between the two.

And there are other intriguing similarities. The ratio of places available in society for successful artists, in relation to the number of art school graduates entering the population each year, is as one-sided as the ratio of politicians to the people they represent. To face such odds, artists and politicians are usually endowed with oversized egos. To believe your work belongs in the climate-controlled caverns of the Museum of Modern Art is akin to assuming your leadership skills are so singular they deserve the trust of an entire constituency. Such confidence may be encouraged in a child, if already present in some form, but is rarely if ever injected through the skin. Basically you're born with it.

Where artists and politicians part ways is in how they respond to the anxiety generated by the opposing private and public influences at work in their lives. Politicians rely on what pundits like to call wiggle room—space that allows officials to change their opinions without excessive exposure to charges of hypocrisy or pandering. Considering what's often at stake in their careers, the flexibility politicians display in adjusting to changing circumstances can be astonishing. What artists exhibit in public, however is assumed by convention to be in harmony

with their most private self. Their work is understood to be unquestionably the product of their individuality, for better or worse. Sincerity is inseparable from the idea of art, as that idea has evolved since Romanticism. Rarely labeled panderers, artists instead risk the more devastating charge of irrelevance. Paintings are private assertions made public. The artist is a free agent, whose work by its nature conveys more intuition than consensus, more expression than convention, and more idiosyncrasy than conformity. A contemporary artist is an individual that moves in, and responds to, an atmosphere of near complete freedom, which can be simultaneously exhilarating and onerous. For unlike a politician, the responsibility of the artist to their work is total and irrevocable.

This freedom is also apparent in the precarious scaffold surrounding an artist's professional standing. Of the many careers you can compare to that of an artist, you are not likely to find one as free of structure. Interestingly, the lack of clearly defined channels of advancement in the arts is one of the more appealing aspects of the profession, particularly to young art students, whose code of dress tends to reflect their comfort with outsider status. Inevitably though, this freedom turns on them, for upon graduation from art school a sense of panic grips many young artists, particularly those with no trust fund to rely on, as they come to realize the next step to take is not there. Society offers no licensing procedure for artists; no bar exam, no petition, no entry level job, and neither guild nor union to appeal to for membership.

Artists dedicated to producing work of genuine and inherent value, as opposed to those extremely rare birds who measure artistic success in economic terms, are engaged in a public conversation involving a dynamic and at times oppressive history, the writing of which is controlled by museums, supported in alarmingly overlapping ways by commercial art galleries and university art departments. Together they offer a counterbalancing architecture to an artist's

structure—free existence. How negotiating this architecture affects an artist's thinking is a significant theme in my own story.

When art enters the public realm by way of an exhibition, the artist's purpose has been at least partially fulfilled. Artists may work as amateurs if they wish, with no interest in exhibiting outside a small circle of family and friends. But to participate in the conversation, exhibiting your art before the public is essential. For me the conversation is everything. If it were not for the conversation I would have become a carpenter. To participate in the conversation is the touchstone of an artist's professionalism. And as this conversation is to some degree internal, issues like subject matter, the role of the artist in society, and the traditions of art—particularly those of modern art, were forces I've had to struggle with all my life. With age, I have arrived at conclusions I could not have predicted back when I was a student. And though you may think my conclusions obvious, considering I paint portraits, no analysis of that fact, let alone an analysis of the canvases themselves, could ever convey a sense of the mental labyrinth through which I've had to travel to get here. What I hope to do in the following pages is to re-trace my steps through that labyrinth. By examining those moments when decisions were made and by exploring the motivations I felt at the time, I hope to gain for my readers, as well as myself, a better understanding of this mysterious thing we call intuition that I have relied on all these years for guidance. In doing so I hope to offer the reader a glimpse of at least one artist's mind.

I qualify in art world lingo as an emerging artist. An emerging artist, for those of you unfamiliar with this peculiar euphemism, is a person who has launched a career as an artist and has not yet died. Unless you're famous you are considered emerging, which has a pleasingly optimistic tone and helps keep the vast majority of painters and sculptors safely nestled in Henry Thoreau's zone of quiet desperation. And as I fit this description all too well, I feel a brief

sketch of my creative development would be more suitable than the rather presumptuous alternative of an autobiography.

Frankly, my life has been too conventional to interest anyone, aside from the topics I have set out above. Though a New York artist, born and bred, I chose to live a life as distant from saturnarian drama as I could manage. And to assure the reader of my credentials as an outwardly ordinary citizen painter I will state for the record that I have never spent a night passed out drunk in the street, nor have I urinated into a collector's fireplace, ran off to live on a South Sea island, slept with a patron's wife, had myself tied to a ship's mast in a storm, fought anyone in a duel, sliced off part of my head, eaten paint, driven my car into a tree or fired a pistol at myself or anyone else. For economic reasons alone, I abandoned the trappings of the bohemian life-style I practiced prior to marriage. The truth is that by the late 1970s it had become too expensive to live as a bohemian in New York, and I had no intention of leaving the center of the art world and the city of my birth.

This narrative then is a revisiting of an intellectual journey. My primary concern throughout its writing was to accurately describe my thoughts and intuitions, as well as the encounters I've had with art, and with artists, that collectively brought me as a painter to this place, at this time, with these opinions.

One

childhood, music and my first taste of college

Vladimir: Question of temperament.
Estragon: Of character.
Vladimir: Nothing you can do about it.
Estragon: No use struggling.
Vladimir: One is what one is.

Samuel Beckett

Until 1974, when I stood across from the registration table at the School of Visual Arts, my art education consisted of what I managed to glean from some rather odd sources lying around the debris fields of popular culture. As to my formal education, it began in 1955 at St. John's School in Kingsbridge, at the far west end of the Bronx where our family of seven occupied an apartment overlooking the Harlem River. Seeing no value in kindergarten, my parents sent this middle child, along with his four siblings, one at a time straight into first grade. Until I graduated from St. Helena High School twelve years later, notably at the far east end of the Bronx, I remained subject to the New York City Catholic school system's religious and academic curriculum. Through considerable financial sacrifice, our parents committed us to this ambitious program, designed to prepare students

for college by concentrating on writing, math and science. Art and music were afterthoughts.

The first indication of my artistic temperament was an inability to concentrate on academics. Diagnosed as the common malady of daydreaming, the particular strain I practiced could be characterized as a habit of staring at compelling visual phenomena. Happily, if my life turned out as the gods intended, I excelled at it. I could be mesmerized by a patch of sunlight on the floor, or the undulating shadow of window mullions on a shade as it waved hypnotically in a spring breeze. To their credit, the nuns, brothers and the many dedicated lay teachers at St. John's understood I was not a fool, merely an underachiever. They apparently noticed I could be as alert or as intelligent as anyone, and I was always well behaved. To my less discerning peers, in their starched blue and white uniforms, I probably looked like an idiot. I was usually near the bottom in ranking, inevitability so as my grades reflected not just ambiguity toward classroom activity but a committed disdain for homework.

To bring your full attention to bear on a task is fundamental to most human activity, and contrary to the school's measure of such things I knew from an early age I had an extraordinary ability for concentration, provided I was concentrating on something I found extraordinarily compelling. One of the reasons artists do poorly in school is that they are self-motivated, perhaps narcissistically so, due to a talent to focus intently on matters most other people would find trivial or irrelevant. But it is precisely the ability to lock visually with appearances that gives a painter the sensitivity needed to produce credible expressions later in life. Unfortunately, it is this same ability that disrupts a very young artist's attention when trying to focus on matters at hand.

To survive school I was able to pay just enough attention to keep up. I read often, but rarely what I was assigned to read. I loved listening to adults in conversation, a persistently undervalued source of knowledge for young people. And yet in spite of my distracted

existence and my poor grades, my eighth grade final exam essay was declared by the teaching staff to be the best in the graduating class, a judgment that caused waves of disbelief among my fellow students, who to be fair had sound reasons for skepticism. But no one was more stunned than I at this completely unexpected news. It was so unexpected my first reaction was embarrassment. I turned beet red. Between my ranking in the class and this out-of-the-blue recognition was an inexplicable gap that stands in stark contrast to a similar event of ironically reversed elements that took place seven years earlier.

Back in the lower grades there were rare opportunities to make art. My favorite sessions were those that teachers used to gain time to grade homework, because in those instances we were left to our own initiatives. But the usual drawing sessions at St. John's were structured affairs. In one memorable instance, it must have been in the first or second grade, the teacher drew three squares on the chalkboard in a pyramid arrangement, one over two, and the block letters A, B and C in each. We were to copy this drawing on our distributed sheets of what I remember as rough newsprint—the perfect surface for crayons.

Having none of the vocabulary in my six-year-old head that I am about to apply in the following description, I made a special attempt to keep my horizontals and verticals true, to keep my squares in a pleasing proportion to the frame, and to choose colors that harmonized with each other. When I was finished I was thrilled with the result. As the teacher walked up and down the aisles reviewing our work she held one student's drawing up to show the class an outstanding specimen. As my own kids would say, I was so not impressed. It looked just plain sloppy to me. The squares were bent and lopsided, the coloring was haphazard, and the proportions way beyond what the paper required. Thinking back now she was probably responding to the enthusiasm of the student's effort. I admit it was nothing if not enthusiastic. She also commented in a more quiet and personal manner on a drawing made by the kid sitting next to me, whose squares appeared to be the size of postage stamps. I wonder

now if perhaps there had been a psychological test of confidence under way. Nevertheless, what mattered to me at the time was how she looked at mine, said nothing and just walked on. I couldn't believe it. I found her indifference stunning.

The significance of this event is not in my teacher's indifference but in my reaction to it. I expected more because I was genuinely convinced my drawing was superior to anything in the room. And it was not a knee-jerk reaction, nor was it merely a child's yearning for attention. I took the time to look around at the other drawings in the room and was unquestionably convinced of my drawing's excellence. Because I was only six at the time, the question of whether my assessment of the drawing was accurate, misguided or delusional is really beside the point. The fact that I felt that way indicates to me the emergence of an artistic ego, sprouting from an innate ability to make aesthetic judgments far in advance of an objective understanding of such things. I could for example instinctively grasp the harmonious textural matching of wax crayon and rough newsprint, while much too young to either express such a thought coherently, or perceive the socially appropriate moment to make such an assertion aloud. Basically, I felt strongly—long before I understood clearly. It was an ability that gave me tremendous confidence in matters related to how things looked.

I should mention that such confidence was not only missing the requisite competence to back it up, but was also in dramatic counterpoint to my otherwise mousy existence. Unassertive in all other respects, I almost never raised my hand to answer a question and until I grew taller endured the role of an undersized pushover in the schoolyard. I would never have, nor did I even imagine the possibility of protesting the perceived injustice to the woman towering over me under her black veil, nor did I harbor a grudge. I felt only that I was in critical disagreement. My judgment of the drawing's quality remained unshaken.

Over the years I have regularly reviewed my work and have on many occasions found a painting or drawing I had thought at the time I made it to be a success, only to realize upon revisiting it that it was in fact a dud. It is a rare occasion when I encounter a piece after many years and feel impressed with how it seems even better than I remembered. On average, I am usually appreciative if an older piece merely holds up. Artists always express the greatest enthusiasm for their most recent work, which leads me to believe an artist's irrationally inflated ego is a survival mechanism. Without an excess of confidence, artists would never make anything. Artists are by nature egotistical. Young art students identify with their work. It is the reason they can get so prickly with their instructors.

There were other early indications of my future career path. On a summer afternoon in the mid-1950s I was one of a gang of seven-year-olds roaming the neighborhood when someone noticed the teenage delivery boy sitting in the window of the butcher shop drawing on a sheet of brown paper. He held an opened comic book in his left hand while copying a figure from its pages with his right, working slowly and carefully with a stubby pencil. Each member of my small group expressed their admiration and wonder at such an incredible feat. Being outside school and among friends I was much less intimidated and spontaneously suggested aloud there was nothing to it. It was a strange thing to assert for the simple reason that I had no way of knowing how easy or difficult it might be. I had never attempted it myself, nor did it ever occur to me to try. But seeing the act performed before my eyes I was struck by the ease with which I felt I could do the same. Not surprisingly, my friends answered this sudden expression of confidence with merciless sarcasm.

Annoyed and indignant, I accepted their implied dare and went home, which was just a few doors away, grabbed a piece of blank paper and a comic book, produced a drawing in about fifteen minutes and presented the evidence to my doubters. To my relief it was a triumph. Several tried it themselves with modest success, but mine still stood

out. Thus began my reputation as someone who could draw. As word spread, I was occasionally called upon to produce announcements for school, but what opportunities lay beyond the occasional poster design remained a mystery. I thought from time to time about being an artist when I grew up, but these thoughts remained abstractions as I had no clear idea as to what an artist actually did. It was easier to imagine the life of a priest, a cop or a subway motorman.

The only model I had was John Nagy, who had a short television program every Saturday morning on which he would talk to the camera while making charcoal drawings. My enthusiasm for his work was curtailed by my utter ignorance of charcoal. I had no idea where to buy it. On the screen it looked like a black lump, which he handled with almost magic control. He also drew quickly which proved intimidating. As an art teacher I have learned that it is a mistake to over emphasize your expertise. It's one thing to demonstrate, it is quite another to show off.

There was one occasion when I actually met an artist. My father worked in an ad agency in midtown. His responsibilities were in office management but he was friendly with everyone, including the art staff. I went to work with him on several occasions before I was ten and had a chance to stroll around the drawing tables in the art department, looking closely at what seemed to me incredible drawings of cars and lettering. During one of these tours an artist actually spoke to me. He joked about how I'd be nuts wanting to follow him into the business. He didn't seem bitter—more like cheerfully cynical. Though not a very encouraging encounter, he gave me a lavish set of colored pencils, which I put to great use at home avoiding homework until they were confiscated.

My exposure to examples of serious art, if only in reproduction, was also fragmented, comprised mostly of images in magazines, text books, paperback covers and stodgy museum postcards distributed once a year by the nuns. Turner, Goya, Gainsborough—they always seemed gloomy to me. I preferred commercial illustration to these

dark, distant images of people in strange costumes. To confuse things more, my world of random imagery included hybrids of the two, like the bad copy of Rembrandt's *Draper's Guild* that appeared on every box of Dutch Masters cigars. Posters of it were in the subways as well. Until I was twelve or so I was more impressed with the paintings of warships on the lids of plastic model kits than the great masters.

At thirteen, another possible aspect of an artist's life made itself known. I discovered my inclination toward non-conformity. Though I was still vague as to the substance of an art career, the idea of being an artist was appealing enough in the face of life as adults lived it in my neighborhood. The intersection of Marble Hill Avenue and West 225th street, where we played ball and spent most of our time, sat in the middle of a gradual incline from the subway exit to the modest heights of Marble Hill itself, with its tenement buildings overlooking the Harlem River. At this intersection there was a concrete barrier that ran along the river side of the street, about three feet high and a block long. It originally served to keep drivers travelling south on Marble Hill Avenue who, if unaware they were approaching a dead end might fly off onto the railroad tracks below. Once the city posted one-way signs facing north the wall lost its purpose. It then became a meeting place for both old and young, conforming by default to the most effective design feature of a public space. It made for comfortable seating and perfect people watching.

After school we often sat on this wall. By five-thirty or so commuters from downtown would march past us in single file on the opposite side of the street. These were mainly family men who all seemed to dress the same—long over coat, fedora, leather shoes, necktie, and a newspaper folded and tucked under the arm. The grade of the hill was just enough to force each man to lean a bit forward, which caused them to appear as if they were stooping, or bowing. At best, their demeanor implied resignation, their measured pace giving the final leg of their commute the unmistakable monotony of a routine. This image was nothing more than a casual observation on my part as I

had not given much thought to where I would be in ten years. At age thirteen, ten years is almost a lifetime.

But one afternoon an unsettling figure joined this parade of commuters. I never knew his name, but he was somewhat older than us, perhaps by six or seven years, and had been the neighborhood guy who bore the most successful imitation of the delinquent, James Dean look of the late 1950s: white tee shirt, black jeans, a greasy gravity-defying pompadour and a perpetual cigarette between his lips. He had been the personification of rebellion and danger. But here he was, wearing the same overcoat, fedora, sensible shoes, conventional haircut, necktie and tucked newspaper, plodding up the hill with the rest of them. I can only guess as to why this particular event gave me such a chill. It might have been the start of my taking the future seriously in the sense that I could suddenly glimpse the end of childhood. Whatever it was, this guy's transformation really hit me. My response was entirely negative. I resolved then and there that I was never going to take a boring office job, live in this same neighborhood and wear a tie every day. What I would do instead was not at all clear, but I was beginning to see what had to be avoided. So by age fifteen I had accumulated a superficial commitment to non-conformity, some drawing skill and by then a highly developed ability to zone out—hardly a life plan. And then there came fully realized role models; images of artists that went far beyond the anachronistic Rembrandt with his over-sized beret that drawing pad manufacturers printed on their covers. I found real artists in the movies.

Double features gave theater patrons a fifty-fifty chance the film presented along with the one they actually bought a ticket for would be worth sitting through. I can no longer remember what the main feature was in the following incident, but a quarter hour into the second feature, called *What a Way to Go*, I got my first glimpse of a "real" artist. It was 1964. The film itself was, as I was able to confirm years later via Netflix, a studio vehicle for Shirley MacLaine's legs. MacLaine's heroine was a bubble-headed female who wished only to

marry and be happy. But each time she married, her husband gained considerable wealth just before a fatal accident, leaving her a rich widow, over and over again. The pattern was repeated, carried along by the absurd notion that with each husband's demise she became increasingly unhappy while growing increasingly rich. Each of her suitors was played by a major star. Paul Newman played a starving American artist working in Paris.

The opening scene in his studio panned a row of very large blank canvases, each draped along the top with paint filled balloons. Brandishing a machine gun, the artist fired sweeping rounds across the balloons, releasing a torrent of random color onto each canvas. The script writer, apparently concerned he might understate the details, included a chimpanzee as a studio assistant. In retrospect I could see it was a full-blown, philistine jumble of Abstract Expressionism and Performance Art and was truly embarrassing to revisit as a seasoned artist. But at age fifteen it added many important clues as to what my mysterious future might hold. Of particular significance to me was a short scene in which the artist wearing paint-stained studio clothing greeted visitors in black tie and evening gowns to his exhibition, while gnawing on a hunk of roasted chicken. This crass stereotyping fixed in my still naive sensibility a measure of the artist's place in society. The black tie crowd came to the exhibition to consider his accomplishments, not the other way around. Here was the non-conformist, able to function through the same persona regardless of whether he was in or out of his element. Most importantly, it confirmed for me the existence of an alternative to wearing a suit, selling insurance and trudging up the street from the subway.

Another aspect of the portrayal that stuck with me was the exhilarating atmosphere of the studio itself. The feeling of freedom, energy and work it represented struck a note deep in my imagination. Art, it said to me, made anything possible. Though I was unable to express an intelligent opinion regarding the character's finished paintings, I was decidedly open to them. In fact, merely considering

their aesthetic value gave me a sense of having a leg up on the audience, for whom it was assumed the paintings would be seen as nonsense. Meant as a visual punch line, I was determined to consider the possibility that they might be serious art. To me they looked exciting.

As the film progressed, Newman's character died at the hands of painting robots he had built in the studio that bore a striking resemblance to a scene in another film I saw a year later; and again only because it was the second feature. In Arthur Penn's *Mickey One*, there is a scene that takes place in the garden of the Museum of Modern Art, in which a fictional artist builds an elaborate sculpture that I recognized many years later as a Jean Tinguely's knock-off. The film itself was dark and by no means a comedy. Once again, a sophisticated black tie crowd dominated the event. Action commenced as the artist set his machine in motion, which soon proceeded to self-destruct as designed, while the bejeweled swells ran for cover, cocktail glasses in hand, from a tidal wave of foam delivered by firemen responding on cue to the planned destruction. Penn's surrealist touches along with his *noir* styling gave the scene a documentary feel, which led me to believe I was getting closer to the truth. But both images of artists seemed hopelessly distant from the rhythm of my life at the time, which consisted of high school…winter break…more high school…summer job…and then more high school.

Each summer I worked as a messenger, running small packages in and out of corporate offices nestled in the shiny new glass towers of mid-town Manhattan. In my senior year I decided to quit the track team and continue working at the messenger agency after school. To do so I had to make the subway by 3:30pm. Though rushed and only able to put in three hours a day, it kept me in pocket money which I felt would help my parents who were paying tuition for five of us. Just squeaking by in my last semester by taking those less ambitious classes offered for the benefit of those just squeaking by, I was well on my way to the only accolades I would earn in four years—perfect attendance

and an absolute avoidance of detention. Then came what turned out to be a fortuitous confrontation with Brother Hugh.

A no-nonsense disciplinarian who preferred the zero-tolerance approach to practically everything, Brother Hugh Arthur caught me standing improperly during the prayer that opened each class. My characteristic level of attentiveness led to a lapse in judgment, as I stood praying with my weight on one leg and the other foot crossed at the ankles, toe to the floor. In Brother Hugh's universe this constituted an infraction worthy of two days detention. When class ended I explained to him I had a job after school and could not report to detention. I explained too that I was willing to perform some other punishment but he remained unmoved, and so I grew indignant. Missing time at work over what I considered a trivial offense was an injustice worthy of resistance. But he too held his ground. With no visible change in his familiarly stern demeanor, he asserted calmly that if I did not attend detention I could not return to class. That afternoon, as I felt was my right as a wage earner, I skipped detention and went to work, and the next day found myself locked out of math class. Lingering in the hall outside Brother Hugh's room, which in a Catholic school was not a situation routinely tolerated, another teacher came by and suggested I could wait in the gym until my fate could be decided.

At the gym, I met Carmine Martelli, who was in a similar predicament. He explained that he had been hanging out in the gym at the same time for several days and assured me no one ever bothered to check the place out. So we continued to meet and talk during what became our unofficial free period. Every day at 2:00pm we would meet in the back row of the gym, light cigarettes, prop our feet up over the seats in front of us and discuss the topics of the day until it was time for home room at 2:50pm. Sharing an unconventional taste in literature, we often discussed our current reading. He would respond to my daily synopsis of *Catch-22* with his daily synopsis of *Candy*. This went on for a week or so before we were discovered by a more proactive teacher who marched the two of us to the Principal's office

to resolve our scheduling issues. I was determined not to give in, and had little fear of the consequences. In yet another indication of an inflated ego, I felt the moral certitude of the entire labor movement. As it turned out, the Principal decided to change both our schedules. I was removed from Brother's Hugh's class and placed in Robert Doyle's advanced English class.

To provide an essential background detail to my sudden entry into Mr. Doyle's class, I must return momentarily to the prior summer. My messenger routes took me in and out of many corporate lobbies, and in one particular instance I happened upon a temporary exhibition showing giant transparencies of Michelangelo's Sistine Chapel frescoes. *The Last Judgment*, a painting I was not familiar with, could be studied in great detail by climbing steps placed before the giant color screen, as if you were ascending a scaffold before the fresco itself. *The Last Judgment's* figures, particularly those in the lower right corner, were the first I saw as I climbed the stairs. I reacted to its depiction of a boatload of hell-bound sinners driven toward awaiting demons with an odd mixture of dread, amusement and confusion. Why for example was there a boat? I understood Hell to be fire, not water. I could appreciate the rather theatrical horror of the demons, but there was one whose large eyes and handlebar mustache bore a disarming resemblance to the comedian Jerry Colonna. It was typical of encounters I had with genuine works of art that they would inevitably trigger links to irrelevant pop culture associations that floated like dust mites in my head.

Further up the stairs a naked figure glared at me as he was pulled downward by demons, his hand covering one side of his face to reveal wide-eyed terror from his right side only. Jerry Colonna seemed harmless, but this other figure delivered a real dramatic punch. He seemed so terrified and so conflicted. Higher still was a man holding what appeared to be the flayed skin of another. The label explained the flayed skin was a self-portrait of the artist. It was too much to take in at once. I could have spent the whole afternoon there, but I had packages

to deliver. I was both impressed and overwhelmed with the complexity of the painting, and disappointed in my ignorance of the figure's identities, having completed eleven years of Catholic school.

Fast forward seven months, back to my new English class. As I took my seat, Mr. Doyle's announced that we were to pick up a copy of *The Inferno* at our little campus bookstore, and assigned us to read the first three cantos. He then launched into Dante's biography, including the political and cultural atmosphere in which he wrote, and specifically how *The Inferno*, part one of a three-part *Divine Comedy* represented an intermingling of ancient pagan mythology with fourteenth-century Christianity, characteristic of the Renaissance that was to follow. I was literally handed a guidebook for Michelangelo's painting. Enlightened as to the identity of the mythological Charon, the ferryman to the underworld that I had mistaken for Jerry Colonna, the comedian was returned to his proper place in showbiz, though at that moment showbiz was for him the Bob Hope USO tour in the strangely parallel environment of 1968 Vietnam—hellfire, boats and all.

I graduated in June, so I was only in the class for three months. But it was in Mr. Doyle's class that I began to connect fragments of knowledge collected from my religious studies, textbooks, newspapers and television, and the few works of art I had seen through reproduction. Together they provided notes I could apply to his lectures while reassessing their meaning. However, the most important aspect of his teaching was that for the first time in my education I heard art discussed as something that mattered; something that was generated from the intellect as well as the imagination. His obvious respect for the material was personal, revealing a deep commitment to culture. Mr. Doyle's approach to teaching was to treat his students as colleagues—not exactly equals, but members of a single pursuit in which he would act as guide. His reading of Dante's words was never rushed or perfunctory and was always preceded by a presentation of background material so effective that his recital of John Ciardi's translation of the eighteenth canto was met by the class with thoughtful

silence: "I saw among the felons of that pit one wraith who might or might not have been tonsured—one could not tell, he was so smeared with shit." This was no small feat. In the room were some of the more boisterous members of the class of 1968. Our infamous graduating class included the instigators and participants of the school's only wall to wall food fight, and was especially notorious for reproducing at a Manhattan screening of *A Man for All Seasons*, the tone and demeanor of a burlesque audience on New Year's Eve. The class of '68 had established a level of boorish behavior so unprecedented, the faculty voted to cancel the traditional faculty-senior football game in disgust. To bring this group of individuals to the vicinity of Dante's guttural metaphors, and to have them respond, at least overtly as scholars, was a testament to the genuine feeling Robert Doyle brought to his reading.

Of more importance to me was how his love for the material opened the door to Humanist thought. His focus was on the substance of the content. There was not much to memorize in this class. Dante's *Inferno* could be read in an afternoon, and the exam was a breeze—though in all honesty that may have been an indication of my selective interest. Ultimately the class gave me something more valuable than an uncharacteristically high grade. It gave me the sense that people who painted pictures and wrote poems had been no less important historical figures than Henry VIII or Napoleon. As a bonus, Dante's grim imagery answered some of the questions I had concerning Michelangelo's actors and began what became a lifetime of study focused on art and church history.

The other bright light in my senior year was the opportunity to enroll in a drafting class offered by Brother Gerard, who was both mechanical drawing teacher, athletic coach and campus contractor. His drafting room on the second floor above the gym was a welcome sanctuary of pencil, paper and silence. I not only did extremely well in his class, I found drafting, along with writing and geometry, proved a vital skill in later years. He was impressed with my work and offered to

speak to people he knew at Pratt Institute about my attending, to assuage what would have been a predictable concern over my grades.

It was a generous offer, but for a variety of reasons I was reluctant to accept it. My concept of an artist was still vague, and I feared Pratt Institute was an exclusively technical school that would channel me off to the life of an industrial draftsman, which did not appeal to me at all. Add to this an odd personality quirk of mine that compels me to this day to resist help on the first offer—an expression of near neurotic independence that drives my wife crazy, yet one I like to think of as just another ingredient in the stew that makes up my peculiar artistic sensibility—and you have some sense of why I spurned an extraordinary opportunity. But the most salient aspect of my decision, a characteristically irrational one considering enrollment in Pratt would have at least sheltered me from the draft and the war, was that I had been learning the guitar, and along with my brother Joe and our friend Paul, I was convinced music was to going to be the outlet of my aesthetic ambitions. And so for the next five years I lived the life of a musician.

Though five years is a considerable length of time, I will not dwell on this period for very long. It was in many respects an extensive detour on the road to becoming a painter. But there were choices I made regarding music that were part of my developing attitude toward creative work, and my growing appreciation for the prerogatives of an artist. It was a period in which I learned a great deal about art and tradition. Many of us spent the greater part of our energy researching the roots that nourished the music of our contemporaries, and along the way developed strong opinions and loyalties. There were times, for example when I felt it was too much of a compromise to play material that might get our cover band more paying jobs, if doing so would misrepresent my sense of authenticity. I could get real pigheaded when it came to debates over art versus business. Instinctively, I felt art always had to come first.

I continued to draw and experiment as an artist with naive little pseudo-surrealist efforts, and I supported myself for a time with a day job at the phone company. But for these five years, visual art was unquestionably placed on the back burner. If there is any one aspect to this detour, aside from artistic and musical concerns, that could summarize its meaning was that for me these years were spent experiencing what most people would characterize as extracurricular college life. It was like having the college experience without all that classroom stuff. I made a great many friends among musicians with whom I have kept in touch over the years. There was considerable time spent in high spirits—no drug euphemism intended—and ironically I was often on college campuses, mostly to play or to hear music. For two of these years I and my circle of musician friends were regular visitors and occasional performers at the Fordham University Coffee House. I never attended Fordham, but I have many fond memories of the place.

At the risk of stating the obvious, there was more to the late 1960s than music. With the Vietnam War and the draft looming in the background, and seeing more clearly the risk I was running by choosing a phone company day job and a part-time music career over a student deferment, my sister Mary managed to facilitate admittance for me to a small liberal arts college where she was attending on a scholarship. I lasted two full semesters, followed immediately by a politely written letter of dismissal. With attempts at twenty-four credits and a 1.7 GPA no one was surprised. I worked very hard at music during this time, but on little else. The only real benefit I gained from my college experience was a one year deferment from the draft. I did not consider the accrual of a student loan a benefit, but it was the only other result of my tenure. It was hopeless from the start. I would get encouraging pep talks from my sister's mentor and foreign language professor, who took an active interest in me. But even I could see her patience wane as my progress failed to materialize. There was an art teacher on staff who taught a painting class, but her over-the-top flamboyant manner did

not appeal to me at all. She had a habit of screaming when she was impressed with something. I couldn't avoid her totally, nor could anyone else as her random bouts of enthusiasm could be heard echoing in the halls. So, except for one music appreciation course, I stuck to basic liberal arts.

Of the remaining course work I signed up for I remember next to nothing. Even the instructor's names remain a blur. I could barely stay awake in theology. I can recall my sociology professor sharing a theory that the automobile's ability to remove its driver from the watchful eyes of their home community was a variable in the sexual revolution worthy of further study. The fact that I had no car at the time is probably the reason why it made such a lasting impression. Of all the instructors who tolerated my decidedly mute presence there was one English professor I recall vividly whose lectures were peppered with entertaining opinions on a variety of extra-poetic subjects. He has since staked a small place for himself in my head where I can still hear his voice declaring to a room of young minds how swallowing raw oysters is like eating snot.

Just prior to getting booted out of school, the Selective Service lottery began and I pulled a fifty-one, which in 1970 was on the wrong side of the cut-off point. Responses from college friends ranged from heartfelt sympathy to guys making throat-cutting gestures as I passed them in the hall. Fortunately, by that time there began a slow decrease in conscription, though to the horror of my family I was called for the physical exam. During the physical, I met a fellow high school graduate, Lamont Dawson, with whom I managed to chat with some awkwardness, considering we were standing in our shoes, socks and jockey shorts. A group of young men in their shorts is a familiar sight to anyone with high school or college athletic experience. Add shoes and socks and those athletes are magically transformed into hapless vaudeville comedians whose pants have just hit the floor.

I couldn't help thinking we were probably meant to look ridiculous as we filed past middle aged sergeants scribbling on clip

boards. There was nothing medical about the atmosphere. It was all linoleum tile and humming fluorescent lamps—more like a pool hall, really. The building itself, immortalized in song by Arlo Guthrie was known simply as Whitehall Street. Both its brick exterior and its iron-bound atrium exuded the dreary gloom of a Dickensian workhouse. My only other memory of the place is the image of a skinny kid with waist-long hair on line with us whose discomfort was made more acute by his decision that morning to wear tall, lime green high-heeled snakeskin boots. He was a walking illustration of how fragile coolness could be, and how closely tied to narrow social contexts were the superficial things we took so seriously in those days—like hair, for instance.

My long hair never dropped lower than the top of my shoulders because it was curly. The longer it grew, the wider it became. For me long hair was a symbol of my identity as a musician. It was not a full-tilt embrace of the counterculture. In the jargon of the day, I was not all that "into" the hippie lifestyle. Many habits and customs of hippie culture seemed peculiar. For one thing, hippies were strangely enamored of the olfactory arts. Personally, I hated all the incense. It not only burned my eyes, it smelled sickeningly artificial. Worse still were the personal fragrances. I once had the misfortune of having to avoid an assured romantic encounter with a pretty blonde because she did not wear the scent of vanilla so much as reek of it. I was afraid I'd become nauseous. Though certainly sympathetic to the sentiments of peace and love, I had no faith in utopian societies. I found the focus on Eastern philosophy intriguing, but even as a child I could not quite pull off the lotus position for more than a few seconds. My joints seemed to be designed for right angles only. I was very much against the war, but I was no further to the left than Eugene McCarthy. Pacifism seemed to me too extreme. What use were pacifists against the Nazis?

My primary concern was always with music, not with the prevailing counterculture, and from what I was able to learn from reading history and from talking with older players, there had always been a strong sense of community among musicians. But many aspects

of the music community overlapped with hippie practices, so much so that they often seemed of one fabric. Like musicians, hippies were never threatening. They offered that real sense of belonging that I enjoyed with musicians. But there were clear differences too.

Hippies could be surprisingly old-fashioned. Though the feminist movement was in full swing, and quite prevalent among the women musicians I knew, the women I encountered in what I would call orthodox hippie environments were often subservient to the men around them, spending hours making bread and waiting on their male counterparts hand and foot. There was also a distinctly sentimental streak to hippie culture. For example, I found Tolkien's, *The Hobbit* a charming little story with memorable, if juvenile characters. But it was suggested to me by several friends that I should read the larger and more popular trilogy. But less than one chapter into the first volume I decided the author was taking his fairy tale much too seriously and gave up on it. I was more comfortable with Joseph Heller's cynicism than with Tolkien's simple-minded notions of good and evil.

Because drugs constituted another overlap of hippie and music cultures, most of my friends considered my aversion to getting high a novel personality trait. I was uncomfortable with anything that interfered with my perception, particularly when playing music in public. I could not understand why any musician would want to cloud their thinking during a performance. In my social life, once I had put a few months of excessive beer drinking behind me, I managed to avoid the dangers of substance abuse. I eventually quit smoking. I was a musician first and foremost—an artist. Everything else was beside the point.

I was most uncomfortable with the hippie social convention of hanging out. When in the company of friends passing joints around for hours in a circle on the floor, I would eventually volunteer to walk someone's dog. I survived many of these social gatherings by a habit of carrying one of my guitars with me. I was hardly unique in this. Other musicians would do the same. The social glue that held me to this

milieu was the fact that hippies loved musicians, so I was always welcome. But hanging out with musicians seemed a better use of my time.

As a summary of my musical exploits will allow me to quicken my return to the more pertinent issue of visual art, I offer the following list of sequential musical associations in which I participated that made up my career detour: One three-man group focused primarily on acoustic folk, blues, etc.; one four-man rock group that played bars and college mixers; one five-man hybrid acoustic/electric group focused on original material. Following this was an intermezzo living in a large house in Westchester originally meant as a means of facilitating rehearsals for the third group, which broke up soon after moving into the house. After various attempts at forming a new group, I eventually quit the house, moved back to the city and formed a five-man rock/blues group with my brother, Joe that played bars for about six months. But in less than a year, by the time disco began dominating the airwaves, the band broke up and I realized it was time to move on. Tired of being penniless, I got a job with United Parcel Service that paid seven dollars an hour, which was good money in 1973. I started on the 10pm to 6am shift, lasted five hours, quit, and ended up waiting for a bus in the middle of Pelham Parkway reconsidering art school.

Alone on a bench at three in the morning, I began reprimanding myself in a loud voice for getting so far off course when it was all too obvious I was neither an entertainer nor a working class hero. During the all-day job interview at United Parcel (which calculates to twice as long as my actual employment) I wondered why they kept asking me if I had ever been arrested. At the circular wash basin during a break on my one night as an employee, it began to dawn on me that I was surrounded by guys with scars, tattoos and distinctly sullen expressions. Apparently—and to their credit—United Parcel had a policy of hiring ex-cons. Perhaps for them this job was a re-commitment to walking the line. For me it was a signal that I was losing altitude and didn't have much farther to go. It was a moment of

genuine transformation. The upshot of my self-inflicted abuse at the bus stop was a resolve to take advantage of what I still had going for me, which was my ability as a visual artist. It was time to do something about it.

I was a good musician, but there were so many better ones. Indeed there were so many, period. As friend and fellow painter Peter Hanssen once said to me, there were more guitar players in the sixties than people. But the truth was, in spite of my abilities as a musician I was never a convincing performer. Fellow musicians either complained, or noticed with amusement, that I did not move very much on stage. I may have sounded like Keith Richards but I behaved like a toll collector. With my penchant for over-rehearsal, and an inclination to take control, I became the reason my last group disbanded. In feeling the need to assert my artistic sensibility, while inconveniently unable to define it, I had created a toxin in the band's chemistry. The difficulty I experienced in discovering my voice within a working group of musicians eroded my confidence in any kind of collaborative art. No more bands for me. I also found it personally unsettling that those who were coming to hear us were getting much younger. All this added up to a growing sense of feeling out of place.

So it came to an end. In a manner of speaking my college days were over. My brother joined another band and did very well, and I got a temporary job in a costume jewelry warehouse on the West Side of Manhattan. It was a low-paying place-holder full of odd little encounters; standing with a recent immigrant from the Caribbean on the loading dock as he watched snow fall for the first time; feeling obliged out of respect for the elderly to endure the elevator operator's smutty tales of conjugal gymnastics, and having the high privilege and distinct honor of receiving several sticks of gum for a Christmas bonus. Sometime in December 1973, having admired their subway posters covered with a field of crayons and a tag line about doing something with your talent, I walked across town to the School of Visual Arts and pushed the door in.

Two

entering art school

"He began to feel a vacancy in himself, the need of something more nutritious to the mind than a play of marionettes."

Louis Sullivan

From the moment I landed my first job as a teenager I had been prowling record stores to augment what became a substantial record collection. As a result, record cover designs constituted the only visual art genre I was thoroughly familiar with. And as the late sixties was the golden age of record cover art, the excitement of that genre may have played a role in my retaining an interest in visual art throughout my years as a musician. Most record designs were photography based, but quite a few included drawing or painting. Knowing their work was to be held at arm's length, a few innovative designers applied minute detail to produce very dense textures, pulling the viewer into the work rather than relying on the more traditional use of bold color and large type that beckoned customers from across the retail aisle. These designs constituted the bulk of my visual education, and so as I signed up for my first semester at the School of Visual Arts,

better known by the acronym SVA, my characteristically vague plan was to work toward the day I could design record covers.

Less than a week into art school I abandoned the record cover plan and became an artist. Of course the transformation was entirely in my mind. I didn't even know what sort of artist I was. But the fog I had wandered through since childhood was rapidly clearing. The fact that my instructors were professional artists made all the difference. They had college degrees, studios in downtown loft buildings, teaching positions, and their work was seen in important galleries and reviewed in newspapers and art magazines. Monday morning at 9am I was in a drawing class with sculptor, Joel Perlman whose tee shirt and jeans now seemed to indicate an entirely different relationship to the world, one more attuned to the environment of Cornell and St. Martin's where Perlman had studied than to the mindless crush of ticket holders I had often been carried along with through the lobby of the Fillmore East. The fine arts suddenly became very real. By Thursday morning of that first week my life had a clear sense of purpose. Though it was a purely instinctive decision, it was hardly an impulsive one. I had been seeking it a long time.

The curriculum at SVA was predetermined for the first two semesters. Called a foundation year, it remains, in my opinion, the only true and measurably effective component of an undergraduate studio program. Of the many benefits it provided for an incoming student, one of its least important, but understandably more appealing aspects was how it made registration a breeze. I was literally handed a program that included one session each of drawing, painting, sculpture, photography, art history, color theory, modern literature and what was then called media arts; a course that served as an introduction to graphic design, illustration and advertising. The foundation year provided each student experience in basic areas of study with a focus on practical application.

Taken seriously, it proved a great deal of work. Being older than most of the others, many of whom had just come from the city's

art high schools, and being in the habit of taking anything that appeals to me very seriously, I got down to work right away. The only apprehension I felt was due to the fact that others seemed more at ease with the tools and materials we used. Though I had worked for a short time in an art supply store, and knew the difference between conté crayon and vine charcoal, I had no real training in how to use them. I had to learn from watching the others.

During my second semester an event of importance to my new life as a visual artist took place at an impromptu student art exhibit put together in James Kearns' painting class. There were two gallery spaces off the lobby of SVA's main building on twenty-third street that stood empty at the time. Mr. Kearns invited us to hang our work in both large and small gallery spaces. I had several pieces in the show, including work from other classes. Someone fashioned posters and placed them in the window near the main door to attract people passing by in the street. We then gathered for our gallery opening. As very few people came in right away, I decided to cross the street to get a coffee. When I returned, I walked into the smaller room where a young couple, having apparently strolled in during my absence, stood before my canvas talking quietly to themselves, occasionally pointing to one part of the picture or another. They showed no interest in buying it, but paid what was my first exhibited canvas, a good amount of time and attention.

Significantly, I discovered I could stand there just a few feet away without identifying myself. I could choose to be invisible. The painting stood in for me. I had found a way to avoid the discomfort I always felt playing music in public. I could now separate my work from myself, while still performing, in a manner of speaking, through the painting. And in a strange way it seemed a more intimate encounter than performing in public. When performing music I was often self-consciously distracted by the public aspect of what I was doing. Now, as an exhibiting painter, it seemed comforting to know the many hours spent laboring on a canvas were never going to be directly part of the

viewing process, while at the same time the fruit of that labor could be reviewed as a finished creation. A viewer could appreciate the canvas, follow my gestures and meditate on whatever evidence I let remain of my adjustments and corrections, without requiring my presence, which I found incredibly liberating. For a musician who could never rehearse too much it felt like a perfect arrangement. To be sure, the next time I found myself in that situation it would be advantageous to speak up, and perhaps make a sale. But strangely enough, the limited transaction between me and the couple studying my work seemed at the time complete as executed.

By the end of the second semester, and for the first time in my educational experience, I had extraordinary grades. Even in photography, which gives me trouble to this day, I managed a B. Everything else was A or A+. My enthusiasm was as predictable as the behavior of a spring that had been wound tightly, and then suddenly allowed to whip loose. All that stored energy gave me a competitive advantage. Students balked when drawing instructor Andy Gerndt insisted on the delicate manipulation of a razor blade in keeping a needle-sharp point on a pencil. I relished its fanaticism. Students complained of boredom in producing those color exercises pioneered by Josef Albers at the *Bauhaus* in the 1930s. I couldn't get enough of them. Some students resisted the vacancy Bill Beckley exposed us to in our reading of *Waiting for Godot*. For me, Beckett was a revelation.

Into the third semester, which was Fall 1974, as I had continued attending through the summer, I became aware of people leaving. Our group had earlier begun separating into those that expressed interest in media arts and those inclined toward fine arts. Though a very small number chose the latter, neither side of this divide held a preponderance of individuals who felt they couldn't handle the work. So the only significant split in the original foundation group, regardless of which direction they chose, was between those that stayed and those that eventually left. By the beginning of my third semester it seemed half the faces from January were gone. Having been a fish out

of water for years, success felt like a genuine vindication. For once I felt symbiotic with my environment.

The most hopeful feature of my new career was that it was indeed a career. Walking across town in the snow that previous December, I was unaware that SVA awarded a Bachelor of Fine Arts degree. I would have settled for a certificate. But a college degree gave me a chance to set things right, and to nurture my renewed education in the only ground that ever felt like home. Prior to art school I would occasionally hear someone characterized as not being, "college material". I never liked the phrase, and after twenty plus years teaching in a community college I care even less for it. But I certainly never considered myself part of such a population, at least in the sense that I was not intimidated by people with greater knowledge than myself. To be honest, I prefer the company of those who know more than I do. It's the only environment in which you can improve yourself. I did not find the curriculum of my earlier college experience intimidating, just irrelevant to my interests. And because I found it irrelevant, no external motivation could change my attitude. I cannot stress this enough. One would think the possibility of shipping out to the Mekong Delta would have been incentive enough to read a text book once in a while. But it was apparently not enough for me. Depending on how you perceive the benefit of being hard-wired as a social anomaly, to be of a single minded purpose is not a handicap once you find the appropriate circumstances for your talent. For me it was the art world. Art gave me an orientation toward studying nearly everything. Neoclassical painting opened a door though which I could better grasp the intricacies of the French Revolution. Counter Reformation disputes made at least a modicum of sense to me once placed in the context of Caravaggio's martyrs. And unlike an art history major, I had the added luxury of hours working in the studio with my hands. Instead of fitting in almost nowhere, I was suddenly comfortable everywhere.

As I advanced through the second year of art school two themes began to surface. There was the work itself, with a daily focus

on the practical aspects of each discipline. And there was the discovery of a subtle, sometimes not so subtle, bias in each instructor. Simmering just below the first year's neatly packaged curriculum were indications that every course was conducted as if it were an independent academy of art. Above and beyond the immediate concerns of the course, instructors offered anecdotes, slide lectures and discussions on contemporary art that, unintentionally or not, exposed a fragmentation of purpose within what had seemed until then a unified program. That no two instructors applied the same method in similar classes was certainly no surprise. But they also expressed radically different perspectives from one another pertaining to fundamental aspects of contemporary art. Each instructor's course was not a syllabus, or an idiosyncratic interpretation of a syllabus so much as a curriculum unto itself—each class a sanctuary for like-minded people.

There was some oversight built into school policy, and each foundation instructor diligently repeated the two mantras of success that formulated the school's program. The first was that if we students wished to succeed we should make the most of what New York had to offer. Routine gallery and museum visits were essential. As individuals we were to keep informed as to what was happening in all art venues. This I performed faithfully for my entire time at school, and continue to do so with somewhat less intensity to this day. To be able to see so much new and old art is one of the great privileges of living in New York. The other mantra was that we were to choose our own path of study once foundation classes were completed. Initially, I found this an exciting prospect. I was finally going to be given the opportunity to work on whatever I found compelling. But along with this new freedom came the school's official assessment system, based on a consensus of professional principles meant to overlay the complex variety of course offerings. The problem with this system was that a consensus of professional principles did not exist.

The assessment process was embodied in the review committee. These committees were groups of approximately four

instructors, randomly constituted, who came around and conducted a critique of each student's updated portfolio. As they were not meant to put anyone in danger of expulsion, to endure a review committee was not a particularly traumatic experience. However, they were not very helpful, and were at times made unpleasant by comments from a committee member whose bias was in conflict with a student's chosen path of study. In and of themselves, the committees were not a bad idea. Why they accomplished so little—which was how most students felt and apparently many instructors, from what I was able to catch from the audible grumbling in the halls during the process—was due to the absence of a standard rubric. A committee's attempt to formulate anything beyond the most banal recommendations would often end up a cacophony of disjointed opinion; the incoherence of which left students simply relieved it was over. Committee members had radically different attitudes regarding student work, and would often express them, sometimes insensitively. To be fair, the majority of reviewers were encouraging, but they were also self-consciously reserved. They seemed to share at least in a consensus that a consensus was unlikely.

The absence of agreement as to what constituted art was not only the main source of dissonance among committee members, but the primary reason for any friction I experienced with instructors during my time at SVA. The standard method for survival was to be aware that instructors attracted those who imitated their own work. Enter Larry Zox's painting class and for the most part you would find students involved in variations of color field painting. John Button's class would be home to representational painters of a wide variety, but rarely if ever would you see an abstract canvas in the room. The advantage of offering classes like these was that students were left free to choose a course of study that appealed to them. The disadvantage was that moving from one class to another could be as unsettling as time travel. Because instructors were free to run the class as they wished, they would present whatever principles were behind their approach in an unintentionally dogmatic manner. For young artists

searching for their own sensibility and strengths, it made the obligatory decision to pick a path more imperative than common sense would have dictated. I liked the freedom of choosing my own path, but I could not understand the rush. I felt there was plenty of time to make an informed choice regarding the direction I might take. I specifically mentioned Larry Zox and John Button because I took their painting classes and found them encouraging, knowledgeable, sympathetic and very good listeners. It was these qualities students often looked to in choosing instructors, if they could not find anyone to actually match their interests, or more importantly, if they had not yet discovered their interests.

A one-on-one relationship between painting students and their instructors has a long history. When the master-apprentice model of the ancient and medieval periods was challenged in the seventeenth-century by government supported art academies, the actual experience of an art student did not change all that much. Students worked with one, maybe two instructors, in a continuation more or less of the master-apprentice model. This resistance to institutional control continued, even as the influence of art academies expanded. The single instructor tradition had become so firmly established that as late as the nineteenth-century, students of the *Ècole Des Beaux Arts*, in Paris received painting instruction at their teacher's studio, not in the school's facilities.

When art departments began appearing in modern American universities they were required to follow the credit system. One class equaled three credits, which required forty-two hours over a twelve week period. Four courses a semester equaled a full time program. This system had been codified by tuition accounting and outside accreditation into an institutional template long before the education of painters and sculptors was shoe-horned into it. However, artist-instructors, each with a stubbornly independent temperament, proved unwilling to submit to such corporate discipline.

At SVA in the 1970s it was rare to find an instructor willing to accept students of widely varying styles. Most felt that when the direction of your work was too far outside the parameters of their class, they would suggest an alternative instructor, which would only reinforce your decision to follow a path you had only tentatively chosen. You became locked into the decisions you made. And if you shrewdly explored several areas at the same time, you would have a better relationship with your individual instructors, but the review committees would judge the discrepancy as indicating poor focus.

Because I was so involved in choosing a path of study, absorbing the realities of contemporary art was my primary concern. The first contemporary art galleries I entered were all in 420 West Broadway. There was a group show on exhibit of which I can only remember a row of standing brown paper bags, draped across the top with a long strip of gauze. I was not impressed with it. In fact most of Robert Rauchenberg's work held little interest for me. I found it appealing only as an important part of the art history puzzle I was assembling in my head. My first trip to the Museum of Modern Art (MoMA) was more memorable. It was a smaller and more intimate museum in the mid-seventies than it is today. Any student from that period would remember Oskar Schlemmer's painting, *Bauhaus Stairway*, depicting students walking to their classes that hung on the landing of the museum stairwell just off the lobby. It implied to me that the stairs were for students, while the elevator at the foot of the stairs was for tourists. The museum at the time was divided evenly between pre-war and post-war art. Picasso's *Guernica* was the first thing you saw in the pre-war galleries along with a room full of studies for the final painting. The collection in the post-war section held special significance for me as it represented the accomplishments of the New York artists of the 1950s and 1960s who were the biggest influence on my instructors' generation. But my initial reactions were mixed. Barnett Newman's large abstraction, *Vir Heroicus Sublimus* made a huge impression on me—but so did Monet's three panel *Waterlilies*.

At the end of one year's studio work, I discovered I had above average ability in producing representational images, and yet I was drawn to geometric abstraction, which seemed to me weightier, more ambitious and more serious than pictures of places and things. Art magazines were the most influential source of knowledge, both for me and apparently for the faculty, as they presented arguments in support of the cutting edge developments on display in galleries. It was from magazines like *Artforum* and *Art in America* that I began learning the outlines of Minimalism.

To describe even the basic tenets of Minimalism would take too much space in such a slender volume. For an idea that celebrated reduction and silence, it produced tomes of critical writing, which was the norm at the time—the simpler an idea, the more verbiage was required to back it up. And to be honest, my grasp at the time of its principles was tenuous. Instead, I will offer a capsule summary of the disparate pieces of modern art history I had cobbled together, to outline what I thought could be explored as a viable thread of the modern, reductivist sensibility. Not only will this summary serve to more cogently represent what I found so attractive about Minimalism—and more importantly why—but will serve as an example of how fashionable and trendy ideas can seduce a young student.

In 1917 Marcel Duchamp, as a member of the Society of Independent Artists, decided to present a sculpture for exhibition that would test the society's claim that they would accept all submissions. Duchamp proposed a piece that was in fact a common porcelain urinal he titled, *Fountain*. Though rejected by the committee, Duchamp had succeeded in earning an historical anecdote to support a particularly iconoclastic approach to art he had been working on since 1913. The *ready-made*, as he called it, introduced into the conversation of modern art the impossible to disprove assertion that art is whatever the artist says it is, bringing modernism's reductive tendencies to one of its early extremes.

Years later and coming from another angle, writer Clement Greenberg argued in the 1950s that the most significant contemporary art was painting that asserted its material reality, championing a style of abstraction that avoided any depth of perspective, and that held to its flatness. Greenberg, the premier formalist critic of his time, was instrumental in establishing Jackson Pollock's reputation as the most important mid-century American painter. Later, the younger Michael Fried in a 1965 catalog essay for the exhibition, *Three American Painters* held at the Fogg Museum at Harvard, took Greenberg's idea further by contending that such artists live life, "…as few are inclined to live it: in a state of continuous and moral alertness."

I found a similar moral theme in a full monograph on the painter Barnett Newman by critic Thomas Hess. Published as a catalog for the 1972 Newman Retrospective at MoMA, it was a romantic biography of a struggling artist that focused on Newman's emphasizing subject matter as crucial to his demandingly abstract canvases. I had been particularly taken by Newman's *Stations of the Cross*, a series of fourteen paintings that focused on Jesus' complaint of having been forsaken by God. I was impressed by Newman's ability to relate abstract painting to both existential and spiritual ideas.

Under Duchamp's spell for about a year, I abandoned him when it became clear he left no room for me to work. Mostly by defending Duchamp's ideas vigorously in conversations with skeptical friends, I had concluded that the inability to disprove something was not proof that it was true. My Catholic school background was helpful in this regard, as I had been exposed to Aquinas' Aristotelian argument for the existence of God, and was always suspicious of its semantic sleight of hand.

I also found both Greenberg's and Fried's extreme formalism unconvincing, not from any ability to parse their dazzling prose, but because the work of Kenneth Noland and Jules Olitski, championed by both writers, did not look to me like serious painting. Though I was willing to consider some of the theories offered by Greenberg and

Fried—and I was always willing to accept a painter's motives as sincere—the canvases exhibited by both Noland and Olitski struck me as arbitrary and decorative. For me, Barnett Newman remained the quintessential abstract painter, and a model artist who stood his ground in the face of severe public rebuke. Both his writing and his painting presented to me the most convincing argument I had encountered for meaningful art. But his approach was so personal, so tied to his sensibility that it was near impossible to get close to what he had done without blatantly imitating it. So I took early Frank Stella as a starting point.

Stella was the other painter in the Michael Fried exhibition at the Fogg. His black paintings, which actually predate the Fogg show, were to my mind the purest expression on canvas of what I understood, right or wrong, to be the Minimalist sensibility. The most archetypal of the series was a tall canvas called *Die Fahne Hoch!*, on which the artist had drawn one centered horizontal and one centered vertical line, both extended to the frame, dividing the canvas into four equal parts. Parallel to these lines were drawn contour lines about three inches apart and repeated until the lines came to the limits of the frame. There was a narrow strip of exposed canvas between the black paint, applied with a brush just wide enough to leave the lines visible. The effect was simple but austere. The entire painting was an echo of itself.

With my rejection of Duchamp's extremism, my respectful distance from Newman's personal approach and with confidence in Stella's methodology, I set to work, with one year of art school behind me, on solving the problem of modern painting. As I understood it, the issue for the contemporary painter was primarily intellectual. All my paintings from this moment until graduation from art school were conceived on a drawing board with a T-square and a triangle—the tools of rational thought. For color, I allowed myself only black and white. My goal was to search for a way to introduce a third element

that would allow the work to advance beyond the first hurdle, which was the cliché of black and white abstract paintings.

I first decided I would use metallic paint for the third element. I felt the reflective quality of aluminum pigment gave a sculptural substance to the painting's surface. I designed a two panel painting, consisting of one square canvas divided vertically with white on the left and silver (aluminum) on the right, and a second canvas two-thirds the width of the first, divided in half, but this time with the silver on the left and the white on the right. By hanging them the same height and a precise distance apart, the silver sections implied a square, spanning from one frame to the other, across the empty wall space between the two panels. Though simple in composition and painted in two colors only, it took me two weeks to complete, partly because I made my own canvas stretchers, but also because I painted many thin layers of each color to keep the texture of the canvas visible and to suppress traces of brushwork. But the aluminum pigment would not cooperate. Its texture proved difficult to control with a brush. On first try it came out streaky, so after two weeks work I had to throw the canvas away and begin from scratch. An enterprising student working in a Rauschenberg style of combine painting immediately salvaged the discarded canvas from the trash and stapled it to his project as a collage element. It was just the kind of facile approach to art that I felt obligated to oppose. Everything I did required careful justification.

I then made another version with spray paint, which avoided the unwanted streaks but made the process all the more complicated, as I had to use the vented area in the sculpture room so as not to asphyxiate everyone in the painting studio. I did a few more versions of this format but I was not all that satisfied with the result. The paintings were certainly elegant looking, but appeared derivative. It was not good to look derivative. I had heard instructors characterize Paul Feeley's canvases as composed of all the shapes Kenneth Noland rejected. Writing about it now makes it sound all too silly, but at the time such pitfalls seemed quite deep, and I felt safer relying on my own judgment,

which told me that my white and silver paintings were derivative, and therefore a failure.

In an attempt to hold fast to the certainty I had felt in my earlier foundation classes, I signed up for an anatomical drawing class with Andy Gerndt. Students were required in this class to make renderings of a biology lab skeleton and various muscle illustrations from anatomy texts. He also had students draw six foot high pencil renderings of figures from art history books on large sheets of brown shipping paper that had the heavy feel of good rag stock but was considerably less expensive. The class drew from the model on this scale as well, but rendering from life on such a large piece of paper seemed awkward to me, so I stuck with art history images for the larger pieces. Rather than draw from Ingres or Leonardo, which were the popular sources among the majority of students, I chose to make drawings from photos of Gian Lorenzo Bernini's seventeenth-century sculpture. I still have one of those oversized drawings today, which is impressive in some ways, but looks to me now like a Neoclassical misreading of a Baroque figure. Andy was always encouraging us to appreciate the figure, and often cited Kenneth Clark's published Mellon lectures, *The Nude* in support of his enthusiasm. Though I heard the term often, the idea of the figure never appealed to me. The term, *figure* somehow separated the person from the image, forcing the notion of allegory, which seemed a hopeless anachronism.

Andy was a generous mentor and recommended me for a studio assistant job with Paul Waldman, a senior faculty member for whom he had worked as a student. Two of us, Devron King and I were given the job of preparing almost fifty wooden panels for a single large painting Waldman was to exhibit at the Leo Castelli Gallery in a year. Each panel received twenty plus coats of trowelled acrylic gesso that was then wet-sanded to a finish that resembled smooth plastic laminate.

On several occasions I assisted in installing Waldman's shows at Castelli. During one installation session sculptor Donald Judd's

assistants were assembling a plywood piece in the adjacent room. It had four sides, each about forty inches high, and about five feet long. The plywood was flawless and cut perfectly, qualities matched by how the assistants handled it as if they were conducting brain surgery. We thought wearing white gloves when lifting Waldman's paintings was extreme. But Judd's people worked on an entirely different level. At one point, the fifth piece of the sculpture was unwrapped and set aside. It was to be placed inside the box-like structure to create an oblique plane that would close the shape. Beveled on all four sides with what looked like machine-precise angles, it seemed perfectly designed. But after several hours they still hadn't placed it. I asked them what was taking so long and they explained that the temperature and humidity of the room had not yet reached the optimum level for a successful fit.

It was inspiring to watch people of such commitment. It confirmed my belief that abstract art was a serious business, appreciated by serious and dedicated people. However, my appreciation lasted for about a month, for only weeks later in the same gallery we were taking a break from dismantling the exhibition, eating lunch in the back room, when Leo Castelli himself came in, accompanied by two well dressed women, and escorted them over to the painting rack. His assistant followed and began pulling canvases out to show the pair. One Roy Lichtenstein came out of the rack, followed by a Frank Stella. The women stepped closer, looked for some time, then quietly asked questions. I was breathless. By chance I found myself a witness to an event rarely seen by students, a sale of an artwork to a serious collector. Then one of the women pulled out a book of fabric swatches and began holding samples up to the painting.

At first it struck me as funny, in that dark sense I admired so much in the films of Stanley Kubrick. Though naturally inclined to skepticism, when faced with such blatant evidence of superficial shopping in the premier gallery of the day I was thrown for a loop. Once resigned to the implications of what I was witnessing I began developing a new sense of cynicism toward the whole art world. In an

instant the balloon I had been floating in had sprung a leak. Here was a collector of important paintings matching a Frank Stella to her sofa. It was a revelation equal in significance to my experience with Judd's gallery assistants, but with the completely opposite effect. How was I going to reconcile interior decoration to my high-minded attitude about contemporary art? By the time we had finished lunch I had revived what had been a dormant appreciation for Marcel Duchamp.

Three

student or artist?

"Modernism, in its best meaning, comprises a development of thoughts and their expression. This cannot be taught and ought not to be taught."

Arnold Schoenberg

Between painting and sculpture; between what had been mostly separate disciplines for centuries, late modernism had created an overlap where one began to take on the appearance of the other. For example, in the years just prior to my enrollment in art school, Frank Stella's paintings had evolved into objects of increasing physicality. To this day his work is still conceived to be hung on a wall, but the space between a Frank Stella painting and the viewer has grown rather crowded. Because I was somewhat comfortable in this new space I tried for the better part of my time at art school to study and practice both painting and sculpture. It was a strategy that often caused problems in managing my time and my very limited resources. But it also provided an unexpected benefit, in that it could keep my instructors slightly off balance. Any bias emanating from their own work could be mitigated by compelling them to cross over into an area

outside their comfort zone. Doing so elicited more interesting and less dogmatic responses. I wrangled critiques of my sculpture from painting instructors and subjected the sculpture staff to discussions about my paintings. In doing so I felt I could keep the conversation focused on the larger question of art, which remained my overriding concern.

There was no strategic thinking to take credit for regarding this cross-over game. It was actually the unintended result of my finding both painting and sculpture significantly linked through a reduction of painting to simple geometric divisions of itself. Doing so increased my awareness of each painting as an object, which led to an interest in materials other than paint. And it was not particularly original, either. It was the era of the shaped canvas, and paintings with either odd perimeters or increased frame depth declared strong three-dimensional properties that spoke to many critical undercurrents of the day.

Of these many theoretical perspectives circulating in the art world of the 1970s, several intersected at a point where the viability of painting was challenged by implying the superiority of sculpture. Artists and critics generally associated with Conceptual Art, like the participants of the landmark *Information* show held at MoMA in 1970, worked as if painting was dead, meaning irrelevant to the concerns of those struggling with advanced art. Hard line conceptual artists actually declared painting dead. But to simply discard painting seemed to me too radical. It made no room for the work of James Rosenquist, for example whose brushwork and color sense I admired immensely. Others shared the less strident notion that sculpture, because it did not rely on illusion, was simply preferable to painting. Many of these voices, notably Donald Judd, Robert Morris and Robert Smithson were artists and writers, a dual role that gave their opinions greater credibility. And yet under the spell of their arguments I still found the notion of sculpture's superiority troublesome. So in the end my straddling the gap between painting and sculpture felt like the best place to be.

As Arthur Koestler noted, what's important is not whether to think inside or outside the box, but to realize that you can think in several boxes at the same time. Everything I did as a student was tentative. I was always open to other ideas. Initially I had only a mild interest in sculpture, until one day during the foundation year when some of us went around to the twenty-first street studios to see the work of a class everyone was talking about. Upon entering the lobby we soon realized the instructor, George Trakas, actually had his students all over the building, not just in the sculpture area. They had rope pieces on the roof, stones mounted on waving steel rods set in holes drilled into the concrete floor, bridges made of planks crossing the space over the loading dock, and objects hanging from the rafters. A complete description of the environment would fall somewhere between a factory and a madhouse. The energy level was intense as everyone was immersed in building.

Some months later I took a trip uptown to see a Trakas exhibition at the CUNY Graduate Center building located on forty-second street, across from the New York Public Library. The work in this exhibition deserves nothing less than a book of its own, so I will limit my comments to just one piece. Right at the entrance, a few feet in from the street there stood a large flat stone a little less than four feet high. The stone was a type of schist indigenous to the New York area, with a surface of exposed mica that, like the forty-second street of legend, glittered. It stood vertically, parallel to the street. About a foot behind the stone was a tall sheet of plate glass, twice as high as the stone and held vertically like a backdrop by means of a simple sawhorse device. Part of the glass was silvered and functioned as a mirror, reflecting the pedestrians in the sunlight beyond the shelter of the building's eave. The mirror part of the glass was an exact duplicate of the stone's shape and size but placed well above it.

I was mesmerized by the work's simplicity and yet overwhelmed with the many interpretations it suggested. While the mirror element created a pictorial rendering of the stone's shape, in

effect transferring the three-dimensional sculptural element to a flat two-dimensional image, the mirror's silvering in the shape of the stone below seemed more metallic and therefore more physical than it would normally appear. The weight and mass of the stone on the ground below sat in counterpoint to the mirage-like mirror version of the shape floating above, like a cloud above the earth. The image of passing pedestrians were reflected in both the transparent glass and the mirror surface, in distinctly different levels of clarity, adding yet another layer of optical complexity. I was almost dizzy from all the readings that seemed possible from a sheet of glass and a rock. Here was an artist who had gone beyond the formalist program of much contemporary sculpture. It wasn't just about interesting shapes. There was something generous about its visual and conceptual complexity.

There were other sculptors working at that time, Jackie Windsor and Robert Grosvenor among them, who were moving away from Minimalism's austere look, by introducing funky, street scarred materials, often subjecting them to various methods of distressing and charring. But these attempts at bringing complexity to the reductivist look seemed stingy, compared to Trakas' ability to add appropriate structural applications to his materials, while creating compelling metaphors related to each material's history. The idea of stingy and generous art was to be important to me in later years. But at this moment, as the idea sat unprocessed in my mind, I was simply preoccupied with how George could assemble such fundamental materials as wood, steel, rope and glass to create sculpture with functional, formal and metaphorical components all working together.

I enrolled in his class the following semester and learned how to weld steel and work with industrial materials ordered from a supplier, rather than the typical art school approach of making sculpture from scrap metal and junk. Upon completing several pieces involving steel and rope, the class was given the challenge of creating a piece that connected outdoors with indoors. Without knowing exactly what I was going to do, I suggested that I would create something

based on an aspect of the city's plan that I found intriguing. Unlike the piazza, or town square of a typical European urban environment, New York's open plazas: Union Square, Times Square, or Columbus Circle; were merely the result of Broadway's diagonally wandering path intersecting the north/south avenues of its grid system. I found its theme of geometry vs. nature appealing. George was very encouraging and gave me complete freedom to work on it outside regular class time.

To begin the process I walked the first few miles of Broadway, from South Ferry to 106th Street, where it curves suddenly and joins the right angle street grid for the remainder of its length. The entire hike took the better part of a day. I stopped now and then to take notes, and I took a great many photographs that when printed on a contact sheet seemed to focus on the shafts of diagonal light from above that sliced the space into light and dark triangles.

The next step was research. I went to the Library at the New-York Historical Society and asked the librarian what was available regarding Manhattan's grid system and Broadway's non-conformist meandering through it. He explained that it was a common question that could be answered in the story of the Commissioner's Map of 1811. Inquiring as to the possibility of actually seeing the map he casually pointed to the horizontal frame hanging just above the card catalog. The Commissioner's Map, about eight feet long and three feet high, outlined the grid system of streets and avenues from Fourteenth to about One Hundred and Fiftieth Street, and from river to river, with the glaring absence of the iconic open space we now call Central Park. Apparently that was added years later.

I was also shown a copy of Valentine's Guide book from the mid-nineteenth century that provided anecdotal information on the period. What I came away with was a clear sense of the commission's success in relieving pressure that had built up between large land owners and speculators on one side, and the city's public interest on the other. More specific to my project was how the path of Broadway was a straight line until it was forced to bend at the Grace Church on

Twelfth Street, which had been constructed decades before the formal paving of roads. North of that point Broadway simply followed an older path called Bloomingdale Road, a meandering street created by a method as old as civilization of following the terrain. By 1811, this road had been so thoroughly developed it was easier to leave its occupants intact and simply superimpose the grid over it. Doing so created, almost by accident, the main centers of the city's design.

I thought the final piece, which at the time was no more than a vague idea, would be a good project to install in the student gallery. Of the two galleries that were off the lobby of the twenty-third street building, the larger had become a space where instructors or administrators mounted exhibitions. The best exhibition I ever saw there was a large group show organized by painter Grégoire Müller, consisting of work by established artists made when they were students, including an Ellsworth Kelly self-portrait and a very small but exquisite *Madonna and Child* by Mark Rothko. The other gallery across the lobby was left for ambitious students to mount their own shows. To obtain access for a few weeks you just had to sign up in advance.

The space was open but for an awkwardly placed steel column, about six inches in diameter, on the side of the gallery that had a lower ceiling height than the rest of the space. This column was off-center on one axis and just three feet or so from the back wall. All I had at this point was a plan to build walls that would recreate the feeling of passing through what writers often refer to as the canyons of Broadway. In this context the column seemed an opportunity. If I were to build a wall across the entrance down to the column, and then around the column from the other side, back up to the section with the higher ceiling, I could in effect create the feeling of walking around the Flatiron Building, which was at the twenty-third street crossing of Broadway just a few blocks west of the gallery. The rounded edge of the Flatiron Building could be imitated by sandwiching the two end pieces of drywall half way across the diameter of the column's width. Knowing visitors would have to walk around the column only inches

from its round edge, I felt the Flatiron reference would become obvious.

In the gallery proper I planned on hanging small handmade maps of each major intersection between Broadway and the grid, from Union Square to One Hundred and Sixth Street. To make professional looking maps I had to teach myself how to use a ruling pen, as all my drafting experience had been in pencil. A ruling pen was not easy to use. It often leaked, ruining the paper and forcing you to start over. It took some practice. For street names I used *presstype*, a kind of pressure sensitive lettering you bought on sheets of waxed paper and transferred to your artwork. A project that today would amount to about an hour's work on a PC (that you could assign to a twelve year old) took me weeks at the drawing table.

When the exhibition opened, most people were impressed with what appeared at the time to be a rare installation piece by a student, though judging from their comments they were not exactly sure what was to be taken away from the experience. For the majority of visitors the Flatiron connection went unnoticed. One visitor panicked, not realizing I had turned the gallery into a cul-de-sac, and shouted for help getting out.

I ended up with mixed feelings about the whole project. On the one hand I was pleased I had succeeded in created a cutting-edge installation. On the other hand, I was not sure what meaning it had for me beyond that. By the end of the period I had been allotted to occupy the gallery, another student followed, with yet another installation involving walls, and presumptuously used part of my wall in his design. Though I was relieved I only had to remove half my debris, I resented his using my lumber and drywall without asking. When his show ended, the school cut the student gallery down to the higher ceiling section and made the wall both our pieces had shared a permanent side of what became an office. So the ironic result of two ambitious student shows was a shrinking of the student gallery.

Back in the mental space I reserved for painting, I was working on several projects at once. This was now my final year. As Fourth Year students (students who had completed six semesters) we were given personal studio space to complete work that would be reviewed regularly, prior to graduation. Our studio instructors were now to act as individual reviewers during the year. We were to receive visits in our work spaces from a variety of instructors each of us had signed up for. A similar structure is used today in most Master of Fine Arts (MFA) programs.

My work space was in the basement. It was a large room I shared with three other students. I took the wide hallway that led to the larger studio area, because it had the longest and most uninterrupted wall space. To provide storage, I built a small loft structure above the double entrance doors. This would keep the space open and conducive to both working and displaying finished pieces. One of the first pieces I completed in this space reflected my renewed faith in Duchampian insurgency. It was a vertical canvas measuring about 40" x 30", painted in monochrome with an intense cadmium red, the surface of which was as smooth and as uniform as an Ellsworth Kelly. I admired Kelly's paintings and so the quality of the paint surface was important. To add the final touch I found a notions shop in the garment district and bought about two yards of one inch wide pink ribbon. I then wrapped a bottom corner of the painting with a diagonal strip of ribbon, stapled to the back, and stapled two longer strips of ribbon on each side of the opposite corner at the top of the canvas. These two were then tied in a bow. The sides of the stretched canvas were deep, about two inches, and were painted with the same red. Thus, hanging in my work space was a painting, wrapped as a gift.

Left untitled, it was a comment made in an unambiguously mocking tone on the "content" of formalist, abstract painting. I followed it up with another piece that began in the woodshop, where I proceeded to rip, cross-cut and assemble a length of California redwood into a simple Shaker-like shelf. I then went shopping in the

local hardware stores in search of paint remover and paint, each can to be chosen for the color of its label as well as its content. I knew paint remover came in yellow cans so the challenge was finding white paint in a blue can and black paint in a red can. Once assembled, the final piece was a shelf on the wall, holding unopened cans of: white paint, paint remover, black paint, paint remover, and so on until it ended with white paint. It was in effect a symmetrical (geometric) painting that was not flat, that didn't even expose the paint to the air, and that made use of Mondrian's three primary colors, plus black and white, punctuated with paint remover, serving as the metaphorical equivalent of the third element I was always searching for. Both pieces were about my frustration in trying to reinvent modern painting. The red one never got a title, and though I utilized a bit of stage direction from a Samuel Beckett mime piece to title the shelf, in the end I referred to it simply as the shelf piece.

Though the difficulty I had created for myself in launching a studio project challenging the essence of painting itself, was exacerbating my increasingly sullen mood, I was working as hard as I had ever worked. Getting the most out of New York had become easier because I had relocated to Manhattan. I found an apartment across town in Chelsea, which decades later, long after I moved away, became the center of the New York gallery scene. Astoundingly, this studio apartment cost me $150 a month. It was a ground level unit with one window facing a gas station, located immediately to the north side of the building, and two small windows at the back that opened onto an alley. Not exactly scenic views, but across the alley was a low, one story structure that allowed the sun to come in much of the day through one of the two back windows. The other window was stuffed with a huge air conditioner that never worked. There was a functioning stove in the kitchen, and a refrigerator that would only open to an elaborately performed series of arm gestures that took some practice to master. Visits from friends who lived in apartments on the Lower East Side confirmed that my vermin infested, but relatively up-to-date

bathroom was far superior to their early twentieth century vermin infested models with the tub in the middle of the kitchen.

The best thing about the place was how quiet it was. At that time Chelsea was a modest working class neighborhood of mostly tenements and small shops, with a few upscale streets lined with brownstones here and there. The actor Anthony Perkins lived around the corner. The sight of Norman Bates walking with his young children had an oddly soothing effect on a brooding art student. I recall too, that there were inexpensive letter size handbills plastered all over lamp posts, announcing a performance artist with the unlikely name of Whoopi Goldberg.

Another benefit of the location was its proximity to the West Village, which complimented the worst part of the location, which was the gas station. Each night a row of trucks would park along the side of the gas station lot. Now and then, invariably at one o'clock in the morning, the last truck to park would bump the one behind it, setting its alarm off about twelve inches from my kitchen window. With its piercing squeal filling my one and a half room domain I would have no choice but to take to the streets of the West Village and walk for an hour or so until the battery on the alarm ran out and I could return and sleep the rest of the night in peace.

Thus liberated from the time and expense of commuting to and from the Bronx, I soaked up the art world. I worked and read and walked the gallery circuit, and read some more, and looked some more; sat in on lectures beyond my registered classes; travelled uptown to Columbia to hear Leo Steinberg lecture on Michelangelo; travelled downtown to the Performance Garage to hear Jerzy Grotowski's history of the Poor Theater as told through a translator; then back uptown to hear Kenneth Noland and Clement Greenberg at the Graduate Center defending Greenberg's removing the paint from David Smith's sculpture; then over to Penn Station where a train took me down to Washington DC to see Barnett Newman's *Stations of the Cross*. I was totally immersed in cultural life and I was taking it very

seriously and working diligently to respond to it. And I was certainly not alone. The fine arts department was a small community, I think there were about ten of us in the graduating class, and each of us kept the other informed of things worth seeing. So when I began to get complaints from instructors that I was not working enough, I resented it.

Most instructors were helpful, each in their own way. Robert Mangold appreciated my inclination toward geometry. Dale Henry applied the better aspects of SVAs informal atmosphere to discussions with students that were never pedantic or patronizing. Carter Ratcliff's lectures (he would answer questions but would not encourage too much discussion) were an opportunity to hear the inner dialogue of a critic. He would present ideas in an unfinished format as if he were opening his notes to us. Andy Gerndt was supportive throughout my time there. He facilitated my getting several jobs beside those working for artists. George Trakas was both an inspiration and a source mind expanding discussions and observations. He also made his truck available for the trip to and from the lumber yard when I bought the materials for my Broadway installation.

Any friction I had with instructors was with those who did not seem to recognize the paradox built into a system of assessment that had no fixed criteria. In one of my first studio visits of the Fourth Year, sculptor Jackie Windsor interrupted my explanation of the problems I had set out to solve, to pronounce that art was simply the act of making things. There were, according to her, no problems to solve. With the greatest confidence she dismissed my entire approach, which needless to say brought our conversation to an abrupt end. In situations when instructors expressed an unwillingness to even consider my work, or when they disliked it and said as much, I was not immune to emotional distress, but I took comfort, as in the case with Windsor, that I saw as little value in her work as she did in mine, though stating that opinion bluntly would not have helped things much. Declaring clear differences between two people does not constitute a

conversation. There was obviously little to gain from such on-the-fly seminars.

On another occasion sculptor Joel Shapiro saw my red painting with the pink bow and dismissed it outright as sophomoric. I tried to get him into a discussion about how I arrived at the idea but he wouldn't accept the painting's premise. Things seemed to improve once I was given an opportunity to summarize the rest of my work, but as I spoke he met every assertion in my explanation with an opposing assertion. In no time at all the conversation deteriorated into what some people recognize as the Socratic method, but to me seemed like forensic ping-pong. For example, when the discussion turned to my disenchantment with popular music, he responded with, "What's wrong with popular music?" Upon suggesting I no longer found it compelling he countered with, "What about Chuck Berry?" Though I felt I had the stronger hand, I resisted seeing his definition of sophomoric by raising it with Berry's lyrics to "My Ding-A-Ling" and opted for ending the conversation on a courteous note. He did express recognition for the shelf piece and a few other things I had in the studio, but definitely not the red painting with the pink bow. That piece always hit a nerve. Most instructors hated it, while many students found it laugh-out-loud funny. Perhaps it was a generational thing, which was unsettling as these instructors were for the most part no more than ten years older than us. Apparently, things were changing faster than any of us imagined.

Susceptible to the typical conceits of a student, I found it easy to judge instructors as patronizing, when in retrospect their attitude seems more an expression of the inevitable animosity between older and younger artists whose fundamental principles in a mere decade had become seriously mismatched. Perhaps subconsciously we could all sense the coming of a post-modern anxiety. Instructors were given the almost impossible task of fabricating a curriculum relevant to a wildly pluralist contemporary art world that resembled the big bang more than an orderly formation of planetary systems. Given the state of

things, it should not have been surprising to find defensive instructors asserting their authority, while their students bristled with indignation.

I still had one more semester to go before graduation. So feeling obligated to pull my ideas together and complete one more project, I was suddenly drawn to the earthy color of the common shale brick.

Four

bricks

"That a glass would melt in heat,
That the water would freeze in cold,
shows that this object is merely a state,
One of many, between two poles. So,
In the metaphysical, there are these poles..."

Wallace Stevens

 Sitting at the drafting table in my basement studio space, holding a measuring tape in my right hand and a brick in my left, I calculated the brick's length to height ratio and transferred it onto paper. I then calculated the proportion of mortar width in a commonly laid brick course and transferred that onto paper. Staring back now from the drafting table were the outlines of two brick faces, separated by a standard measure of what would be the mortar between them. Instinctively I filled one brick shaped rectangle with black and left the other white. I was not ready to give up on my black/white aesthetic. I could now visualize them as painted panels, each about five feet long. The five foot scale was easily calculated once I became comfortable with my rendering of four actual size bricks to be inserted into the

panels, again in the pattern of a conventional brick course with standard distances between them.

As this description exceeds the complexity of the others I have asked the reader to endure in various parts of this narrative, I thought a quick pencil sketch would be in order.

From left to right, the first and fourth brick would be embedded entirely in the painted panels. The second and third bricks would each cantilever between the painted panels to within the same distance as the mortar separation - about three-eighths of an inch, so as to complete a four brick course running from the left black panel, across the space and onto the right white panel. Reading from left to right the set of four bricks would in effect span the distance between the black and the white painted panels in proportion to an actual brick course, while the panels themselves would hang from each other at a distance equal to the mortar/brick ratio, but on a larger scale.

As with all my other paintings, the brick painting (this one never had a title either) was conceived entirely on the drawing board. There were practical details to be worked out, but I could do most of that on paper as well. To fit the bricks neatly into the rectangular holes cut into the panels, I dressed them on a belt sander. This perfected each brick's dimensions to within a sixteenth of an inch, sharpened each brick's corners, and removed the kiln glaze of the face to expose the ceramic body beneath the surface. Exposing each brick's granular consistency helped emphasize its color, which I felt de-emphasized its sculptural mass. To keep the cantilevered pair level I used screw-type window locks that could fine-tune the correct pitch of each brick while remaining invisible from the front. Each panel surface had to float about three inches off the exhibition wall to accommodate the width of the bricks, so the carpentry for each panel's backing had to include a

hanging rod. This rod made it easier to slide the panels left and right on the wall which allowed for fine-tuning horizontal distances.

When it was finished I hung it in the studio space and stood back. Its effect actually surprised me. It went far beyond what I had envisioned. It had a presence, even a grandeur that visitors responded to immediately upon seeing it. It demanded the attention of all who entered the room. The muted red of the bricks made for a perfect mid-tone to the black and white extreme of the two panels. From about ten feet away the bricks appeared as artificial as the paint. Only when you approached to within a foot or two did you realize they were masonry. The consensus among visitors was enthusiastic and very gratifying. People literally stopped in their tracks to stare at it.

So having created a successful prototype, my job now was to develop variations, which turned out to be more difficult than I had expected. No matter what variation I tried: vertical panels with just one brick spanning the two, three panels extending almost sixteen feet across the room, one panel with many bricks stacked one over the other; all failed to make it off the drawing table. No arrangement seemed to equal, let alone improve on the original. Worse still, every variation seemed arbitrary. The way the original version harmonized the proportion of the bricks, the way the ratio of bricks to panels balanced the composition, the way the finality of black and white acted as a foil to the earthy red of the bricks, all conspired to limit what I had hoped was going to be a series of paintings, to yet another piece in my studio with no particular relation to any other piece.

Though the painting was a huge success in terms of how it was received, it was a failure in the sense that I could not develop it into related work as the program required. In other words, I was making more progress as an artist than I was as a student. I remained in the same perplexing no-man's-land, stretching between a hard won portfolio with all the ancillary study that informed it, and the ever urging obligation to produce a coherent body of work.

I knew I had to continue with more drawings to try and resolve the problem of variations, and I would have been willing to do so had it not been for my being placed on probation. Of all the complaints I received from various instructors concerning my work, and how my portfolio still seemed thin, this most extraordinary objection came in my last semester. In yet another indication of the phantom consensus supposedly applied to the assessment of student work, several instructors were offering to write letters of recommendation for me, encouraging me to apply to MFA programs, while others, looking at the same body of work, were suggesting I may not even graduate. Facing a desperate situation, my only leverage was in relinquishing the rigid position I had taken in avoiding arbitrary (aesthetic) choices. By removing that self-imposed burden I could at least produce a few variations on the brick painting.

This was a difficult adjustment to make, as that position had been my most cherished guiding principle. And as I write about it now, it is as amusing to me—as I'm sure it must be to the reader—to witness an artist acquiescing to something as fundamental to art as the making of aesthetic choices. But such were the demands of the ideological channel I had been sailing through. For no other reason than the will to finish school and move on with my life, I resolved to salvage what I could from the brick problem, even if I had to make "arbitrary" choices.

What I came up with was a plan to make nine single-panel rectangles, with one brick outline in the center of each. I would then treat each brick outline differently. One would be an actual brick, one a painted image of a brick, one an empty cavity the shape of a brick, one a black rectangle that looked like a cavity, etc. I no longer recall all of them. Once again I found myself relying on humor, as the new brick panels were in many ways mocking the original. While I was busy with the logistics of completing this one last project, I was visited by the instructor who was assigned to my case—my "probation officer."

Richard Van Buren, whose cast resin sculpture I had seen examples of in both the Paula Cooper Gallery and in the Philadelphia Museum of Art, was given the job of reviewing my probation status. In a slightly apologetic tone that immediately put me at ease, he explained that to put probation behind me I had only to convince him of my portfolio's worth. I was more than prepared for this. It was easy to present my work, and the thinking behind it, to someone open to listening. Though I had not produced great quantities of work, I was able to impress him with the quality of each project and my ability to convey my knowledge of contemporary issues in relation to each piece. With that out of the way, the rest of the conversation meandered into the awkwardness we both felt toward the whole idea of probation. Apparently he was just as aware of how producing a body of work in the pluralist seventies would inevitably place students at odds with half their instructors. His candor was very much appreciated.

The school's inability to see that my portfolio indicated how I had conducted myself exactly as they had suggested, was a constant source of irritation, and what convinced me to stick it out through graduation was often no more than the empathy I could sense from a few instructors, whose informal comments revealed their own discomfort with the general uncertainty in the school's educational goals. I found this informality both welcome and unnerving, particularly coming from a more structured educational background in which a faculty member's challenge to basic principles would have been inconceivable.

The day to day atmosphere at SVA was nothing if not relaxed. It was rare to hear an instructor addressed formally. There were exceptions. Though I certainly don't recall anyone using the term professor, let alone doctor, Bill Murphy reminded me recently that our mutual painting teacher, James Kearns was unique in how he insisted on Mr. Kearns. Almost everyone else was John, Hannah or George. In Robert Murray's sculpture class I was once notified by a sign posted at the entrance to the studio that I was one of several students that had

not yet shown the instructor their work. Murray was not exactly formal but his demeanor reflected the courteous manner of his native Canada more than the streets of Lower Manhattan. He had asked a student to make this list, and to post it on the wall over the tool shop. But he probably had something in mind like: Will the following students please see the instructor as soon as possible, signed, B. Murray. Instead, with the freehand lettering panache art students cannot seem to resist, the oak tag sheet hanging over the tool shop read in big bold type: BOB MURRAY'S SHIT LIST, with the names of the offenders listed neatly below. From what I could gather from René Lavaggi in the tool shop, Bob didn't care much for it.

René Lavaggi was himself an informal asset to the school. Much of the practical knowledge needed for labor in the sculpture studio came as a bonus to anyone borrowing tools from René who served as the studio manager. René Lavaggi was in his sixties when I was there. He was not only the manager of the sculpture studio, he was often an unofficial instructor. A master stone carver who had been Isamu Noguchi's studio assistant when he was younger, he had a knowledge of stone and other materials none of the younger instructors could match.

René learned his craft among those members of that loose affiliation of independent spirits that had been the pre-war New York art world. Many of its members were still around, but somewhat under the radar. One afternoon while returning unused welding rods to the tool room, I was introduced to sculptor Phillip Pavia, who had stopped in to say hello to him. They knew each other from the old days. And yet with such real world credentials, René's could never teach a course, because he did not have a college degree. And frankly, some faculty members were inclined to dismiss stone carving as irrelevant to contemporary art, though the celebrated event outlined below put those who asserted that opinion in an odd predicament.

When Pop Art sculptor Claus Oldenburg wished to have his design of a bicycle seat replicated in marble, René was recommended to

him by Hannah Wilke, who was on SVAs sculpture faculty at the time. Winning Oldenburg's trust, René completed the project right there in the school's twenty-first street studio. With pneumatic hammer in hand, a paper bag hat on his head and several pairs of calipers nearby; he duplicated in a large block of Carrara marble the image given him in a small resin maquette. When it was complete, the artist stopped by to look it over and fell into a discussion with René about signatures. Oldenburg insisted René put his signature on the piece as well as his own. René balked at the idea of including his own name, but eventually gave in. Then Oldenburg dashed off his stylish signature in pencil on a yellow legal pad, which René reproduced perfectly on the marble surface in less than fifteen minutes, using nothing but a small pointed chisel and a hammer. He then added his own smaller autograph below.

Just in time for the final review, the nine panel brick project was finished. As to the results, I was of two minds. Most were successful in their modest way, and as expected, the superiority of the original was never surpassed. But they accomplished their goal and I was cleared to graduate. As the big day grew near, I concentrated on getting as many instructors to visit the studio as I could. Everyone was still impressed with the original brick painting, but comments varied. Grégoire Müller offered the intriguing, and to be honest slightly discomforting opinion that the brick painting was wonderful and would have fit perfectly in the Bykert Gallery, which we both knew had been defunct for several years.

Many visitors wanted to know if I planned on making more. Though I kept it to myself, I was quite finished with bricks. In fact I was quite finished with Minimalism. I was ready to move in an entirely different direction. And yet Carroll Janis, who was the director of the Sidney Janis Gallery, and who had been my last art history instructor, expressed real enthusiasm for the brick painting. He was very encouraging and suggested when I was out of school and settled that I should come by the gallery and say hello. This was as unexpected as it was extraordinary. To have a major gallery interested in you right out

of school seemed too good to be true. It may be more common today, but in 1977 it was rare.

In the last week we were told to clear our studio spaces, so I emptied mine out with a vengeance. With a friend waiting upstairs in a truck, I entered the studio at 7am, gathered everything up, loaded the truck, dismantled the loft storage above the door, pulled the hooks out of the wall, plastered the holes, returned the drawing table to the room where I had found it a year earlier, swept the floor clean and disappeared by 8:30am. I wanted to make a dramatic exit. I wanted my studio space to seem a sudden, empty void. It wasn't going to be enough to just walk out. I had to vacate the premises as emphatically as I could. I wished more than anything else to separate myself from the stifling conundrum of taking my education so seriously it interfered with school. In years since, I have characterized my time at the School of Visual Arts as the most significant of any time in my life. I still tell people that SVA provided me with everything I needed as a young artist, but unfortunately insisted on including so much other nonsense that it took me a year to get over the place. The last thing I did before leaving for good was to take all the brick paintings and throw them on the trash pile in the refuse room down the hall. I was going to begin my life as an artist with a private studio, an open calendar and a clear head.

I was not angry, just relieved my student days were coming to an end. And I was certainly not bitter. I had no reason to be. I graduated with a Bachelor of Fine Arts degree, attended the graduation ceremony with my family at the Rogers Auditorium in the Metropolitan Museum of Art, and felt the serenity of knowing from that moment on how my life was to be dedicated. And just as the best things that happened to me in high school happened just before leaving, so during the last few weeks of school I began dating the woman that I have been now married to for thirty-four years. The first time Susan and I spoke was when I registered a complaint to the SVA library about how a set of slides were labeled. As a favorite of mine I was particularly

knowledgeable about Barnett Newman's *Stations of the Cross* and when an instructor made reference in a lecture to each station's iconographic title, i.e., *Third Station, Jesus Falls the First Time,* etc. I objected. The actual title was *Third Station* - period. Newman had explained the irrelevance of the narrative iconography to his paintings in an artist statement accompanying the first exhibition of the series at the Guggenheim in 1966. I had managed in 1975 to purchase one of the last catalogs in the museum bookstore.

When the class was over I volunteered to deliver the slides to the library, along with my complaint about their mislabeling, which I presented to the desk clerk. Noting my complaint, the clerk called the Head librarian who in turn called Slide Librarian, Susan Kramer, who listened patiently but seemed to be resisting the temptation to suggest I should not be explaining to a librarian how to do her job. The library staff had minimal contact with students and therefore less experience with the presumptuous, opinionated manner to which I and my peers often subjected our instructors. Considering the generally sullen mood I was in the last few weeks of school I was surprised I wasn't more annoyed by her resentment. The reason, of course, was that I had become distracted by what incredibly beautiful hands she had. With apparently no conscious effort on her part she could achieve those delicate hand gestures common in Botticelli's portraits. In fact her whole appearance was like a Botticelli.

Around the same time I landed the position of door checker in the same library. Of all the odd jobs I had as a student this was the easiest, but the least pleasant. They hired students to sit by the exit door and check patron's bags on the way out, to prevent the theft of books. What began as a slightly embarrassing assignment deteriorated to daily mortification, as several instructors, whose protests against their inclusion among the usual suspects failed to persuade the library staff to waive the rule for them, chose to express their displeasure by showing contempt for the door checker. With grand theatrical flair they would indignantly fling their attaché cases or shoulder bags open and

dare me to look inside. But apart from these occasional confrontations all I really had to do was sit there, read art magazines and chat with the staff. Of all the conversational partners available to me at my post I preferred Susan. She was a big opera fan and I had recently spent half my rent money on a subscription to hear all nine Mahler symphonies at Carnegie Hall. We also shared a working class background and a sense of humor that belied our cultural preferences. I wanted very much to ask her out, but I felt the absurd position I had in the library lacked the social standing needed to impress a sophisticated and beautiful woman with a Masters degree and a real job.

 While sitting at my post by the door we would engage in longer and more interesting conversations, during which I was becoming preoccupied with working up the courage to ask her out. Whether she was sending positive signals back to me I couldn't tell. I was never very good at picking up signals. In a pattern that would be repeated for years to come Susan's impatience with my obtuse reception would impel her to send signals that could not go unnoticed. So there began a series of encounters between us when taking a break from her responsibilities supervising the slide staff she would come over to the main desk that overlooked my guard post to shoot rubber bands at me.

Five

a reluctant graduate student

" [New York is] a city where everybody mutinies but no one deserts."
Harry Hershfield

By September 1978 Susan and I were married and I was back across the river, this time in Queens. Having grown up on the banks of the Harlem River looking across to Manhattan, my arrival as a student and resident onto the island itself was as exciting for me as it was for friends at school who came from Long Island, Pennsylvania, Texas and Japan. Manhattan seemed to be the center of everything. But as my time ended at SVA, Manhattan was becoming increasingly uninhabitable for those whose careers prevented their considering income as their main focus. Rent was on the rise, and as friends were losing their lofts it became clear that my tiny studio apartment in Chelsea was not just doomed to an upgrade, but no match, even if renovated, for a sun-drenched apartment, triple its size across the river in Sunnyside. So that's where we settled. Just one block from the number seven train, which could bring me back to Manhattan in twenty minutes. If necessary I could walk over the 59th Street Bridge in

little under an hour. Sunnyside was hardly an artist enclave, but I had become immune to the lure of the art ghetto. I had learned along with many others that as soon as artists transform a neighborhood, the stock brokers and lawyers move in and rents skyrocket. Artists are never safe in any neighborhood for long. I resigned myself to considering the entire city my neighborhood and to live where it was most convenient.

Susan already had a career and a good job. My plans were to work part-time, make art three days a week, and within a year or so begin exhibiting. I liked the idea of teaching, but I was adamantly against returning to school for a Masters degree. From what I could gather, there was little an MFA could offer a graduate of a professional art school. Most programs looked identical to the program I had just completed. It seemed absurd to repeat a course of study. I thought, foolishly as it turned out, that teaching positions would be awarded solely on a candidate's portfolio. Apparently I had a great deal to learn about the professional control artists had already surrendered to academia.

Though I continued studying the work of a number of painters, I remained convinced sculpture represented the more promising path to ambitious art. But I could hardly make sculpture in a two bedroom apartment—certainly not the sculpture I was interested in. I wanted to build. Neither carving nor modeling were ever a part of my vision. What appealed to me about the sculpture of the mid-seventies was its aesthetic of built structures. For a period just prior to graduation I even considered architecture, but the thought of having to please a client's taste reminded me of the endless compromises I had faced as a musician, not to mention the difficulty I had reconciling collaboration of any kind with my solitary working methods. I rejected that route.

My reliance on solitude also left me reluctant to return to school. To make art within the parameters of any school program is to agree to a collaboration of sorts, and the most troublesome aspect of those collaborations was the inevitable critique of unfinished work.

Discussing a completed work of art is to fulfill its purpose. But a conversation about a work in progress becomes exasperating. It's not possible to bring a stranger into a mental process and still maintain a coherent train of intuitive thought. It renders suggestions offered by your colleagues slightly impertinent and annoying, and more often than not makes for bad conversation.

I did not want any more school, but I certainly needed a place to work. And a studio, separate from our living arrangements, meant an increase in monthly rent, which meant a larger and more reliable income than my current and sporadic handyman business. Because Susan's father was the manager of a large hardware store on Queens Boulevard, just around the corner, she proposed I work there. Around the same time, I applied for a position of assistant preparator at the Guggenheim Museum. During the interview at the museum I was given a tour of the facilities, including those sections of Frank Lloyd Wright's building the public rarely saw in those days: triangular elevators and so forth. What the staff at the Guggenheim wanted was a person who could handle artwork, matte and frame delicate works on paper, hang paintings, install sculpture, load and unload crates, work forty hours a week, seven days a week during the installation or striking of exhibitions and take on other odd duties as they came up—all for about $6500 a year. The hardware store needed a clerk and locksmith four days a week plus Saturday and offered $7500 a year. So I became a hardware clerk and neighborhood locksmith. George Trakas, with whom I stayed in touch since his leaving SVA to work full time on commissions, suggested that a locksmith was the equivalent of a, "psychological musician". Comparing the sound of a lock dividing a private and public space to that of a musical instrument is classic Trakas. A poetic sensibility can find meaning in the most mundane events.

With a steady income in place, I was able to rent a studio in Hell's Kitchen, about two blocks from the Port Authority bus terminal. It was a bizarre, ground floor space in one of the ziggurat style

buildings of the garment district, measuring about eight-hundred square feet, with a twelve-foot ceiling, a concrete floor, one giant square column off center near the entrance, no plumbing and absolutely no light other than two fluorescent fixtures, also off center. There was one small window that opened to the base of an airshaft in the back, but it had been painted over from the outside. Even when open, the light it provided was hopelessly inadequate. With the entrance just off the lobby, it was hard to imagine what the original architect thought tenants were going to do with such a space. It was cold, dark and damp—like a cave. But it was mine, and I would report to work each Friday with my coffee and my tool bag.

 I was able to buy small quantities of lumber nearby, though I was limited to what I could carry on any one trip. Someone had left a large hand truck in the space that I put to use gathering material from the desolate rail yards nearby. The rail yards were my main source of supplies, mostly gravel and large stones that I planned on using for weight and support for the wood structures I intended to build. No one ever bothered me as I collected materials in the vast open space. Aside from truck drivers and a few rather sad looking hookers, there was hardly anyone around. Back at the studio I was beginning a project that would entail the building of a long piece, the head of which was to be a house like shape with a roof beam cantilevered out in front to support a rope with a large stone hanging from it. The rope would create a plumb that would be amplified visually by peering at it through two closely paired two-by-fours serving as a facade. Though it was not all that complicated, it took me almost a month and a half to finish, as I could only work on it occasionally.

 The part of the project I completed was a light weight structure made of materials costing no more than fifty dollars. But adding that cost to studio rent, which was about $285 a month, I ended up taking on extra jobs to pay for it all. On occasion, the studio helped with this. As a student I had worked for Dennis Martin, a busy commercial photographer in Murray Hill. He called and asked if I could paint him a

textured backdrop, which I was able to produce quickly as I now had a space to fabricate large work. The earnings from that job were set aside for rent and supplies. But if keeping the studio was going to require more time earning rent money, on top of completing my hours at the store, how was I going to find the time to make art? After several months I became so frustrated at having a large studio sitting idle, while I was elsewhere earning the money to pay for rent and lumber, I stopped at a midtown stationary store one day, purchased a dozen 34 x 40 cardboard sheets, bought a few colors, a brush and a pint of turpentine from the hardware store and began to paint again.

This abrupt switch from sculpture to painting may appear eccentric, even opportunistic. But for me to try and explain it by trotting out some facile notion of artistic freedom would serve only to undermine one of the more significant themes of this narrative, which is the driving necessity to create. Freedom has nothing to do with it. There is actually little freedom in acceding to an irresistible impulse, an impulse that compelled me to work visually with ideas as those ideas developed conceptually. Being unable to do so for lack of time and supplies was as frustrating as anything I had experienced in art school. Moreover, my art school experience taught me that thinking about a piece, without acting on it immediately, leads to a fondness for the idea that often fails to live up to its perceived promise. To keep working, therefore was more important than a commitment to any specific medium.

So when it occurred to me that I was unable to spend enough time in the sculpture studio to work as I wished, I simply returned to painting. To me, it didn't seem an odd decision at all. I had spent as much time making paintings as I had making sculpture. But more importantly, I had been comfortable in an artist's skin for many years, even during my musical interlude. So moving from one medium to another was far less traumatic than the prospect of not working at all. All it took to create a crisis situation were economic limitations

preventing me from working toward realizing what that impulse would not relent.

In the same cavernous studio I now began painting (so I thought) like Willem de Kooning. Until this moment I had only painted carefully constructed geometric abstraction. To explore an expressionist's method felt as liberating as art school had been in the first months. Surprisingly, its most basic functions proved a challenge. The first thing I learned was that the slashing brush stroke of Abstract Expressionism was not actually slashed. On the very first painting I loaded my brush and whacked it across the rectangle. It felt very authentic to do so, but almost none of the paint stuck to the picture. Most of it ended up splattered on the wall to my right. A slower, easier stroke improved adhesion only slightly. By the time I found the correct pressure and velocity, the gesture had deteriorated from a slash to a gentle back-handed slap against the surface, followed by a slightly slower tug to the right. The visual result was finally as I had wished, a hybrid stroke somewhere between Willem de Kooning and Franz Kline. But the method was entirely counterintuitive, considering Abstract Expressionism's tough guy mythology. I had been convinced I had to attack the canvas. Apparently the most effective pantomime was not much different than what Anthony Van Dyke would have performed in the seventeenth century rendering a bit of drapery.

The first few paintings became entirely overworked. I just kept adding paint until I had a mess. I really didn't care. I was intoxicated at first with the freedom of moving color around. But I soon adjusted to a gradually steeper learning curve. With each sheet of cardboard used, I was connecting a specific tactile feel to types of strokes and effects I had seen in paintings from many different periods. By afternoon's end I had a sound appreciation for remarks de Kooning once made regarding Peter Paul Rubens and the compatibility of depicted flesh with the consistency of oil paint. I began to feel how oil paint could be compatible with depicting anything. For the next two sessions in the studio, which were a week apart because I was still working extra to

make the rent, I began improvising pictures that had little or no connection to each other. I was doing very much the opposite of what a painter does when trying to produce a coherent body of work. And as I progressed, it suddenly occurred to me that I could break the lease on the studio, continue working at home and spend the money I had been losing to studio rent for better quality art supplies. The pace of work I was able to sustain, and the feeling of release from the notion that only sculpture could produce ambitious art, helped me realize painting was the medium for which I was best suited.

Back in Queens, I set myself up in the extra bedroom and continued painting. Relying on spontaneity as the painters of the fifties had done, I could see early on that the look and touch of Abstract Expressionism could be imitated only by making a conscious effort to do so. So I kept clear of too much imitation. Such mimicry had no place in what I was doing. My purpose was to discover clues that might indicate where I may be going. I was not looking for just anything, and I was not looking for a solution to a clearly defined set of problems. I was simply trying to discover what I was about.

What I first noticed was that I had a tendency to see spatial illusion everywhere in the picture. Before the painters of the fifties launched into the oversized canvases we associate with that decade, most of them had passed through a surrealist phase that stretched from the war years to about 1948. These early canvases were not only smaller, but revealed a comfort level with the modest spatial illusion typical of post-cubist abstraction. Adhering to a somewhat shallow depth, each artist nevertheless seemed comfortable with a figure/ground distinction that allowed for biomorphic or natural imagery. The space I often caught a glimpse of in my own work was much deeper than that. I saw landscape, and more significantly, landscape light, in everything. No matter what I did it ended up looking to me like a depiction of an outdoor place. Even though I consciously avoided anything resembling an established style, there was a feeling in

each painting, at least for me, that there were vast spaces beyond the picture plane.

A month or so after breaking the lease, I paid a visit to the Sidney Janis Gallery, which was still located on 57th street. Keeping his promise, Carroll stepped out from the back office and took me around through the group show he had on the walls at the time. Group shows at the Janis Gallery were like museum exhibitions. The gallery's private collection included Mondrian, Brancusi, Picasso and a host of other early modern masters. We strolled around, talked about each piece and discussed the work of a new artist he had discovered in California whose painting—a stark, black and white geometric abstraction—was hanging in the back room. He inquired as to how my work was coming along and I told him I was finishing up a new series and would soon bring him slides. He seemed pleased and said he was looking forward to seeing them.

When I completed the task of photographing the new work I sent the slides off in the mail, addressed to Carroll at the gallery. Two weeks later I stopped by only to discover he had seen the work and was no longer interested. We left together, as he had an appointment, and as we walked along 57th street we made small talk. He noted the Weavers Reunion poster near the entrance to Carnegie Hall. I learned he had been a big fan of theirs as a college student and I talked a bit about my own musical background. His familiarity with the Weavers dated him as somewhat older than most of my other instructors at SVA. When I got a chance I asked him point blank what it was about my new work that caused him to lose interest. He said that I had been doing really compelling work at school, but now I seemed to be, "...going backwards."

Though disappointing, it was not really a shock. I was aware that there were many smaller bets that had to be made to get into a high stakes game. Yet proximity to winning can blur reality, like the false sense of just missing when you discover the number on your lottery ticket is one digit off the winning set. Though you'll never

convince a gambler of this, if you need the number three to win, then four is really no closer than nineteen. But what was not so easy to shake off was how Carroll had such little interest in the work I was now producing, when he had been so enthusiastic about my earlier efforts. My thinking had been that if he liked the brick paintings so much he would have been willing to invest in the artist who created them, no matter what that artist chose to make. I was beginning to realize that the appeal invisibility once held for me as an art student was based on an incomplete understanding of an artist's role in the business of art. Apparently an artist could also be literally invisible, in that the art itself could be embraced by the system, while the artist remained an easily replaceable source. There are thousands of them out there.

To be fair, Carroll showed rare confidence in his initial judgment. When a gallery owner encourages a young artist, even slightly, there is a danger the artist will perceive an arrangement where there is none, and when things don't work out, the artist is likely to throw a fit. It is really no easier to personally run an art gallery than it is to be an artist. In many respects it is more difficult. But that wasn't my problem. I was an artist not a gallery owner, and at this moment I was faced with interpreting what had just happened. Was I going to read this event as a missed opportunity? Would it have been worth it to just knock off a few more brick paintings? In answering that question I would suggest that the reader recall how I had faced a similar question in 1970, when merely embracing college would have removed the risk of being sent to war. But back then, as with my just recounted brush with success, I was apparently incapable of doing anything other than what my artistic impulses required. Practicality was no match for the siren call of a muse.

As difficult as it was to face the implications of this harsher reality, I was never in doubt as to my decision. As I saw it, the only viable path was to rely on how I felt. I may have blown a chance at early success, but success first had to happen in the studio. I had to be

enthusiastic about my work before I could share in anyone else's enthusiasm for it. It was unfortunate to have lost all interest in the brick paintings as soon as I left school. But I felt too that I had my whole life to develop a career, and the only guide I could rely on was my own sensibility. Though I may prove delusional in my enthusiasm for work that I will later judge as a failure, I must, if I am to make art of any meaning, believe in the value of what I make at the time I'm making it. To follow someone else's instincts is to become an employee.

I interpreted Carroll's backwards comment as a reference to my swimming against the current modern art's progress. Perhaps what he had perceived in the brick paintings was a fresh variation on a style of painting that could trace its lineage back through Ellsworth Kelly, Barnett Newman, Piet Mondrian and Kasmir Malevich; a thesis to which his gallery was particularly committed. But I was drifting, as were many younger painters at the time, in a variety of unorthodox directions. To us, it was more complicated than simply backward and forward. The last wind of an art movement was to be felt in less than ten years. By 1990, after the sails of the Neo-Expressionist ship went slack, there were no more art movements. The pluralist flotsam that had defined late modernism scattered into the doldrums of a post-modern who-knows-what. For some galleries, the loss of a dominant mainstream was traumatic. For critics and theorists it was both a crisis and an opportunity. But for artists, it provided badly needed breathing space. For many artists, Post Modernism, as it came to be called (in the hope that it would behave like just another art movement—which it never did) at least exposed the forward-looking interpretation of modern art to be a metaphor, not the historical imperative so many had assumed it to be. For younger artists, a new sense of freedom came with the arrest of that once relentless forward movement.

It had been several years since I left art school and apparently the prognosis for my gaining access to a gallery was going to be extended much further than I had originally envisioned. Of the many

aspects of married life that have a positive effect on one's self-perception, honest and objective criticism from someone who loves you is a particularly valuable asset. In this spirit, Susan began chipping away at those arguments I had piled up against the pursuit of a Masters degree. Trusting the wisdom of her counsel, I began looking into a few Masters programs. Limiting my choices to those within an hour's commute, I sent slides and resumes to Queens College, Hunter College, and to the education schools at NYU and Columbia. My reason for including education programs was that I was not entirely disabused of the notion that repeating art school would be a waste of time. Perhaps the study of actually teaching art, which was the ultimate purpose of pursuing a Masters anyway, would prove useful, particularly as I felt so strongly about the curriculum I had experienced at SVA.

Sitting in the hall with a line of Hunter MFA hopefuls, I was determined not to rehearse a speech for the interview. I thought it best just to wing it and answer whatever questions the interviewer threw at me. As I sat there, I could not help but overhear a conversation between two candidates, sitting across the hall, who were discussing a panel they had attended, either on the topic of conceptual art or partially focused on it—I couldn't be sure. What I clearly remember was one telling the other that Meyer Shapiro's comments on conceptual art showed that he was, "...clearly out of his depth." As a casual comment it could perhaps be dismissed as youthful arrogance, but to my ear it went beyond conceit. It revealed either a stunning ignorance of Shapiro's writing, or more likely, an indication of conceptual art's residue settling comfortably into the academy.

When it came time for my interview I entered a small office where Robert Swain sat looking down at my transcript, and without looking up asked in monotone why I wanted to attend Hunter's MFA program. As I finished explaining my interest in teaching and my appreciation of the school's proximity to several major museums, he looked up long enough to show he was clearly unimpressed. Friends later suggested that at that point I should have named the artists on

their faculty with whom I hoped to study. Unfortunately, I had no such faculty members in mind. I knew Swain's work and could not see anything in it that I had not already grasped on my own. And I was certainly not going to fall again into the trap of studying art through the eyes of a discordant faculty, each with their own narrow agenda. The Art History staff at Hunter was extraordinary, but most art departments in and around the city had equally impressive historians.

Next stop was Queens College, whose administration sent me a letter several months after I applied, explaining that without slides of my work they could not reach a decision. I telephoned to clarify that I had indeed sent a whole sheet of slides. Promising to look into the matter they sent another letter, apologizing for having lost the slides behind a copy machine, and indicated they would get back to me soon. Then a third letter came stating that after reviewing my work they felt I should take a course or two at the Studio School on Eighth Street, then reapply. A week after that discouraging news, I received a phone call from Herb Aach, who I believe was the chairman of the department, apologizing for the more recent letter's inappropriate suggestion (I had a BFA from a professional art school, not a BA in liberal arts) and inviting me to the college for an interview.

On the day of the interview I found Aach and another faculty member, a woman whose name I regret I have forgotten, in a sunny office overlooking what was then a campus of great open spaces. Rather than a formal interview, Aach, who did most of the talking, conducted a pleasant conversation in which he explained that what they did at Queens was not much different than what they did at SVA, but that he was sure the faculty at Queens would do it better. Then sculptor Lawrence Fane took me on a tour of the facilities and back to the office, where I was offered admission. I thanked them and told them I would let them know in a short time if I could accept.

Next came NYU. I entered Professor Robert Kaupelis' office and took a seat opposite his large desk. A wiry, energetic man in a black turtle neck, Kaupelis was animated and very friendly. He explained that

their program was actually designed to prepare artists for teaching positions in elementary and high schools. He reviewed the difference between NYU's MA and NYU's MFA, which confirmed what I had suspected, that the real difference between the two was about sixteen more credits of studio work. That prospect was not the least bit appealing. I preferred the freedom of working on my own to paying twice the undergraduate tuition for the privilege of doing in a campus studio what I was already doing at home. If I was to return to school, it would be for a program of study that would address the problems I encountered as a student.

At Teachers College, Columbia, I was interviewed by Professor Justin Schorr, the senior painter on the graduate faculty. I immediately liked him. He had a Zen like calmness about him. He explained that their program was different than NYUs in that they actually offered a Masters degree in painting, and that he taught a seminar in teaching art on the college level. He urged me to enroll in the accelerated Masters/Doctoral program. Though I was initially intrigued by the doctoral idea, I realized it would really be a Doctorate in art education, not painting. (Though there is always threatening talk of establishing one, I believe we have been spared thus far the absurdity of a Doctorate in painting.) The MFA still remains the terminal studio degree. If I chose Teachers College I would not have to commit any further than the Masters, and could always reconsider the Doctorate later.

Hunter turned me down, Queens was not only disorganized but admitted they were going to repeat my undergraduate program, and NYU seemed inappropriate. So I decided on Teachers College. By taking two courses each semester I could meet tuition payments without loans, complete the program in about three years and still keep my day job. After one semester, I decided I was not going to pursue a Doctorate. The equation was not difficult to solve. If I were to spend five plus years on coursework, plus the time it took to write a dissertation (which would have been on the history and practice of

undergraduate studio art programs in comparison to traditional art schools) while working full time to support Susan and myself, where would I find the time to paint? How could I qualify for a faculty position in an art department with a Doctorate in how to run the place but no paintings to show? How could I be an effective painting instructor without actually painting? Or more to the point, what did all this have to do with being an artist? I decided to earn my MA in painting and move on.

Justin Schorr proved to be the most objective and the most sensitive painting instructor I ever had the pleasure of studying with. He had no interest, as most painting instructors seemed to have, in projecting a singular viewpoint that merely reinforced the underpinnings of his own work. He was almost without ego. This was not a personality trait, he had studied the contemplative practices of many cultures and managed to gain a considerable lucidity in his understanding of an artist's life, and more importantly, an understanding of the teaching of art as actually practiced.

What I thought would be the centerpiece of my studies was Schorr's seminar on teaching art on the undergraduate level. Sitting at the head of a long table, he found himself with two groups facing each other on either side. On one side there were the typical Teachers College students, who were not as focused on their careers as artists, but who were committed to teaching at all levels. This group included several Doctoral students who already held undergraduate faculty positions. On the other side were four students who came from the Columbia Graduate School MFA program and were mirror images of what I and my fellow students had been at SVA—overconfident and frustrated with their instructors. After twelve weeks we were as far from a consensus as any group of artists I've met before or since. Everyone had their pet peeve and their favorite theory. There was however one conspicuous moment of unison. When I made a presentation about how the Josef Albers color exercises were as rewarding, and as influential as any project I had completed as an

undergraduate, I thought I was going to be run out of the room. That particular episode of art school, apparently universal in the nation's foundation curricula, topped everyone's list of projects never again to be imposed on students—an opinion I found baffling. Why was everyone so adamantly against a simple color exercise? Inconclusive as a seminar, it succeeded I suppose as a group therapy session.

Surprisingly, some of the more standard education courses proved more valuable. Lawrence Cremin's course on the history of American education focused on his basic premise that education does not happen exclusively in the school; that newspapers, social clubs, employment, good television, bad movies and a host of other cultural sources enriched and complemented the formal education of the classroom. At the time he was the college president and working on the third and final volume of his history of American education, and so lectured sporadically. The heavy lifting for the course was the responsibility of Ellen Lagemann. What we were assigned to do in the course was to select about twenty books from a long list of titles dealing with American history and culture, and identify how each relates to education on some level. A report then had to be written with all our findings. It was the most reading and the most writing I had done until then. What impressed me the most about the reading was how it reflected my own peculiar experience. Learning to be an artist through imagery collected from Hollywood fluff, corporate lobby exhibitions and record covers, marked me as a living example of Cremin's thesis.

As for my painting courses, they were like all the other studio courses I had taken, mostly group critiques. Honestly, I was not that focused on this part of the program. I was developing as a painter on my own and I did not care much about what anyone thought of my working methods. I only cared if they thought my finished canvases meant anything to them. In a typical critique session I would tell the group up front that I was not interested in their ideas as to which red would work better, or how the composition might balance if a certain

element were to be changed. I was confident in my grasp of formal properties. But I would explain that I was very much interested in what their thoughts might be regarding the work's potential to communicate something. At the time I was painting landscape-like canvases of intense color combinations that were both abstract and suggestive of limited atmospheric illusion. But it bothered me that each person responded to my paintings according to their own narrow preconceptions. Six people would interpret a canvas six entirely different ways.

Most people thought the paintings were visually strong, but aside from garnering a few compliments, they failed as pictures to start a conversation of any substance. I asked myself, why was it that Susan and I could see a film or read a novel together and talk about it for days afterwards, but painting critiques seemed only to generate superficial comparisons to other artist's work? With the landscape elements stubbornly asserting themselves through the abstract density of each canvas, and with my newly found interest in nineteenth century landscape painters, I decided to drop abstraction and return to a representational mode. It was a simple as that. If I was thinking of trees as I painted, I thought; why not just paint a tree? In doing so I was following Willem de Kooning's anecdotal wisdom, often quoted by artists, "...at first it seemed absurd to paint a woman, and then it seemed absurd not to". Few in the history of modern art have matched his eloquence.

Step one was the decision to paint representationally. Step two was to address the question of what to paint. The answer came one Saturday, as Susan and I decided to take the boat ride around Manhattan that has been a staple of tourist activity in the city since the 1950s. These were the same boats I had watched sail past my window as a child. Knowing I was to pass my boyhood home, I brought my camera along, and just as we sailed under the Broadway Bridge I snapped away at the five story tenement still standing above the Metro North tracks overlooking the Harlem River. Even with the distracting

task of getting a good shot, facing the building from the river and watching it gently glide by created a momentary encounter with the past that triggered a flood of memories and feelings from as far back as I could remember, all while seeming strange and distant. I decided this image would make the best beginning for my debut as a born again realist.

Back at the studio, I began planning the canvas. I first made a careful drawing, a portrait of sorts of the building's brick and sandstone facade, then placed this image slightly off-center, with the hill, the tracks and the river forming a deep foreground in the lower half. Assured the attention of the viewer would be drawn to the façade, I then began drawing the other buildings that lined the street, when it occurred to me they were extraneous to the subject. I was interested in the viewer's focus on this one building as an urban image in odd proximity to the rural character of the river—John Sloan meets Winslow Homer. I decided then to leave the street on both sides of the building open to a cloudless blue sky.

When I submitted the painting to my class critique the group suddenly came alive. They could have discussed it for a week. Beside the formal aspects of the canvas, beside its painterly properties, it had an intriguing and perhaps even theatrical quality I was very pleased with. In its symmetry and in its direct confrontation with the viewer I felt I had finally moved beyond Minimalism by appropriating one of its key elements. With a minimal composition, emphasized by the peculiar solitude of a row house standing parallel to the picture plane, confronting the viewer in foursquare geometry, I had in a sense created a representational-minimalist-landscape painting. But I had also created a landscape metaphor, suggesting the passing of time as well as the underlying rural layer beneath all urban settings.

To me it also revealed the continuing influence of Barnett Newman on my work. What had always appealed to me about Newman's painting was how each canvas confronted the viewer. I felt that to contemplate the verticals, or zips as he liked to call them, in a

Newman painting was to stand at the location where he once stood, facing the void of an empty canvas. Having read much of Newman's writing I'm confident he would have dismissed such an idea as nostalgic. But as much as I admire the precision of his thinking and the clarity of his writing, I found a sense of truth in this interpretation, and could support my perspective by applying Harold Bloom's notion of creative misreading. To my eye, a painting of a solitary tenement building, under a blue sky, perpendicular to a streaming river, addressed the viewer in an abstract manner, not unlike how Newman addressed his viewers, but through the iconography of an urban landscape painting.

Unexpectedly, as my emancipation from Minimalism was nearly complete, I was given a chance to revisit it in a show held at PS1 in Long Island City. At the exhibition was Robert Morris's wheel, which until then I had only seen in photographs; several Jo Baer paintings, and a few paintings by my teacher, Robert Mangold. There were others, but these three I remember vividly because they were in poor physical condition. Morris's wheel had a surface of peeling paint. Robert Mangold's panels were badly warped, distorting the crucial geometry formed by the lines that separated each panel, and Jo Baer's paintings, which had been of the series painted with geometric figures wrapping around the sides of each panel, were smeared with very noticeable fingerprints, scuffs and other traces of mishandling. Regardless of how these pieces came to look the way they did, their less-than-pristine appearance undermined something that until then I had not recognized as perhaps the unique characteristic that made them so appealing to me as a student. Without the clean, sharp corners, the illusion of purity failed. Without the flawless surface, the idea of Minimalism languished, with no visual support for its ideological context.

Seeing the work in that condition triggered an art school memory I had filed away in the back of my head. One afternoon, while entering a classroom in which Donald Kuspit was ending a lecture, I

heard him pose a question to the class that I can remember well enough to paraphrase:

Why in the 1960s with the war, the drugs, the urban riots, the assassinations, the confrontations with Southern sheriffs, the rebellious music - why in this period of tremendous social upheaval was Minimalism's cold, cerebral style so dominant?

My first reaction to hearing the question was, why hadn't so obvious a notion ever crossed my mind? Why had I never heard it expressed by anyone else? It was a question that touched on both my infatuation with Minimalism and my admittedly reluctant immersion in the counterculture of the period. And yet I had never thought myself of linking them. Now, having seen the PS1 exhibition, an answer to that question suddenly came to me. Perhaps there was a 1960s counter-cultural aspect to Minimalism as a particularly potent visual expression of youth. The damaged specimen at PS1 now seemed middle-aged, instead of merely neglected. Apparently for me, part of Minimalism's appeal had been its perfection, which I had subconsciously connected to the taut flesh and ideological innocence of life under thirty.

And like a chain reaction, that connection brought to yet another one—an interview I had read as a student, conducted by Moira Roth, with Robert Smithson in which he challenged Duchamp's decadent mystification of the art object. Though I was unsure as a student how to react to Smithson's comments, I remembered how unusual it was at the time for anyone associated with the avant-garde to trash as eminent a figure as Duchamp. Apparently, Smithson's argument, along with his fascination with decay and entropy, had planted a seed in my mind containing a sense of the breakdown in Modernism's historical narrative. This dormant clue, combined with Carroll Janis' backwards comment, and the PS1 show filtered through Kuspit's question, gave me confidence in the idea that there was indeed more to art than the charismatic look of an object in an immaculate white room. Generally speaking, I learned too that I would always do better following my gut as I worked, then forming an index of

theoretical ideas after, when the work is complete. To place a theory at the head of a search for a creative path is a bad idea.

A highlight of my graduate work at Columbia was Barbara Novak's course in the history of American painting. Even before I made the switch to representational art, I had become increasingly interested in Thomas Cole, Sanford Gifford and John Frederick Kensett, mainly for the light in their work. Novak's lectures not only focused on these and other landscape painters, but on the general strain of spirituality in the Luminist tradition of American landscape painting, that related to both my own landscape tendencies, and to the explorations of myth by Carl Jung, Joseph Campbell and Mircea Eliade that I had begun reading as an undergraduate. In a lame attempt to render all this stuff into an academic soup, I wrote my required Master's thesis around a large painting I composed just for the thesis project, based on the American civil war battle of Antietam, which I loaded with references to myth, religion and mysticism. It was dreadful, and became immediately irrelevant to me upon submission. In and of itself, it held my interest for the duration of its construction, but the impetus for the entire project was simply the degree requirement to produce a thesis. Like the weak, follow-up brick paintings I did at SVA in order to graduate, I had to write something if I was going to get my Masters degree from Teachers College.

And as before, just as I approach the end of another barely tolerable school program, a positive opportunity arose. It was suggested to me that I should look into the college teaching internship, available through the department. Though traditionally offered to students in the ceramics area, I convinced Bill Mahoney, the chairman of my department, to enroll me as a painting/drawing intern at the same school. He agreed, and I was sent to Kingsborough Community College, a school I had never heard of until then. Apparently, it was one of the newer community colleges in the City University system. Located at the southern end of Brooklyn, the campus sat on an

incredibly beautiful peninsula that stretched into Sheepshead bay and the Rockaway Inlet.

Six

artists and students

"Creative activity could be described as a type of learning process where teacher and pupil are located in the same individual."

Arthur Koestler

On arrival at Kingsborough, Tom Nonn, the chairperson of the art department explained that my intern assignment would be to work with him exclusively in his drawing and painting classes. I learned much later that the reason he insisted I work with him was a desire to avoid repeating an unpleasant encounter that had occurred between a previous graduate intern and the professor to whom he had been assigned. As far as I was concerned it was a stroke of luck, as it provided an opportunity to show what I could do under the watchful eyes of the person who hired part-time instructors. My observation of Tom Nonn's classes progressed during this first semester from helping out, to an offer to conduct critiques, which eventually led to several days of actual student teaching. The following semester I was hired as an adjunct to teach a drawing class, which was fortuitous for several reasons. It provided a boost to my income, but also went a long way toward clarifying how a part-time teaching position was never going to

provide enough funds to allow me to quit the hardware store. Having a father-in-law for a boss helped considerably, as I was able to leave an hour early twice a week to teach my class, but with the birth of our daughter, Melville (pronounced mel-veél, as her great grandmother was called) the pressure was on to provide a more substantial income.

The art department at Kingsborough had several large, well equipped studios, including three generous spaces of identical dimension for drawing, painting and sculpture. In addition, there was one slightly smaller space for photography, a printmaking studio that had been originally designed as a physics lab, and a ceramics studio with both gas and electric kilns. Further down the long hall was a 2200 square foot art gallery, under the direction of Lilly Wei that held several exhibitions a year. For an art department in a two year community college it was an impressive facility, and had apparently proven to be difficult to maintain without an individual managing full oversight. After one semester as an adjunct instructor, the chairperson suggested I submit an application for a full-time studio technician and gallery assistant job that was about to open. I must have seemed a good candidate as I was a practicing painter with experience installing professional exhibitions, as well as skills in carpentry, welding, tool maintenance, black and white photography and a variety of other areas.

Both Professor Nonn and the college Provost, Michael Zibrin made it clear to me it was a tenure track position, but not of faculty rank. They explained that even though I was overqualified for the job with my Masters from Columbia, it was not an MFA and therefore inadequate for faculty status. The fact that the job did not qualify as a faculty position did not bother me so much at the time. The chance at a secure, full-time position was quite an offer on its own merit. As described, the job would allow me to teach one course each semester, provided it was scheduled before or after my regular hours. Susan and I discussed it and both of us felt it was too good to turn down. After interviewing for the job it took a few weeks before I received the welcome news that I had been hired.

Because my responsibilities extended into the studios and the art gallery, I became involved in one way or another, with most department policy discussions. I was very comfortable with this, for even as the lowest ranking member of the staff, I could never be dissuaded from offering opinions. I had developed quite a few over the years. Though I had no special ability to see farther down the road than anyone else, it became apparent in conversation with my new colleagues that as the youngest member I seemed to have a greater concern for where the department was headed. The majority of faculty had fought their battles earlier, and in doing so had established a sound, functioning organization they felt needed little adjustment. Feeling less satisfied with the department's performance, in relation to what I saw as its potential, my impatience with the slow rate of change would occasionally stir things up between the chairperson and myself. Because I worked so closely with Tom Nonn, our differing views on art education surfaced more often than with the others.

Tom was a hardworking and dedicated painter, who as chairman of the department applied his special talents for diplomacy and prudence in dealing with Deans and other college principals toward maintaining the department as configured. My lack of authority to carry changes through to completion required Tom's support, who as chairman was understandably reluctant to cause friction with the administration over issues I advocated for, but for which he did not feel any urgency. But on balance I appreciated how the faculty, especially Tom extended to me the freedom to address departmental issues at a level considerably above my official station. Though only rarely did they act on my suggestions, they never discouraged me from expressing them.

A big part of my job was the installation of exhibitions in the art gallery, and of particular interest to me was how the annual student exhibition was conducted. After mounting this very large show about five times in as many years I made the choice to lobby for a revised method of selection, as there were many problems with how it was

done—problems I interpreted as having to do with an institutional hesitation to examine whether the values of the department's curriculum correlated with those of the art world. The faculty had decided long before I got there on structuring the annual student exhibition like a jury show. Students would each submit three pieces of work from the past year. A professional artist or critic would be invited to come to the college, review submitted work, choose what they felt were the best pieces for exhibition and select a few for special awards. Implied in this method was the supposition that any art professional could be counted on to choose work of which the faculty would naturally concur.

In conjunction with this student exhibition, Leon Goldstein, the charismatic president of the college, selected the recipients of his own Presidential Art Award and chose the winners himself from the work selected by the juror. There were no problems there, as his choices reflected personal taste. My concerns were with the selection of the show itself. I had no real interest in awards. Now and then I proposed that awards ought to be dropped altogether, but I was consistently alone in my opinion. Glenn Gould's essay, "We Who are About to be Disqualified Salute You", remains my guide concerning art awards and competitions.

But the exhibition itself was another matter. Not only did I object to the cumbersome logistics of a jury process, I emphasized how each year there were complaints registered regarding dissonant choices made by that year's juror. Being especially attuned from my art school experience to the discordance of a poorly defined assessment system, I tried to no avail persuading enough faculty members to abandon the juror approach and seek a process reflecting the influence of department instructors on their own student's work.

Then one year, entirely by chance, an artist was chosen as juror whose critical eye, we later discovered, reflected a decidedly funky version of the 1980s Lower East Side gallery scene. The result was that this juror's choices were frankly difficult to distinguish from work most

of the instructors would have considered inept. An uncooperative student, who had barely avoided failing Jack Bolen's painting class by dashing off a required assignment in ten minutes, found his desperate little canvas singled out by the juror as the best painting in the group. Beside himself with a perverse glee you could hardly blame him for, he marched to the podium during the award ceremony to accept his prize, while it became Jack's unenviable task to explain this choice as best he could to the rest of his class.

Jack was not alone. So many faculty members were dismayed by the juror's choices prior to the opening of the exhibit that they took it upon themselves to create an award for a particularly gifted student, in an attempt to right what they perceived as an unfortunate rejection of his work. But what was intended as a corrective measure backfired when the student, voicing his displeasure at the podium, told the assembled students, faculty and administrators that the award meant nothing to him because his work wasn't considered good enough to hang on the walls. His considerable ire, expressed dramatically from the limited elevation of his wheelchair, quickly deflated the ceremony's festive atmosphere. But even in light of that fiasco, the more significant offense was absorbed in stoic silence by a majority of instructors who saw the better examples of their student's efforts disqualified from the exhibit in extraordinary numbers.

Apparently, what had been missing all along was a head-on collision between value systems. It took a dramatic event like this to persuade everyone to face the growing discordance between what we were teaching in our studio classes and what was currently celebrated in the art world. It was particularly true for us at Kingsborough because we were a two year institution, which meant we only taught foundation courses. As such, we rarely faced the pervasive art school dilemma demonstrated when studio undergraduates abandon principles learned in a foundation program in pursuit of the endless revolutions that define contemporary art.

To be clear as to the meaning of what had happened, it's important to note that the juror executed their office with sincerity and professionalism. Everyone involved operated in good faith. The result was a mess because everyone assumed, erroneously as it turned out, that they were applying the same criteria when judging student work. The exhibition's unfortunate outcome demonstrated not just a lack of harmony between our program and the art world, but a real gulf between the two. There may yet be a consensus among the majority of undergraduate art departments across the country regarding values expressed through their foundation studio programs. But their collegial harmony does little to address the distance that has widened between art as taught and art as exhibited. The two remain almost foreign to each other, as if education and practice were in alternate worlds. That the juror's selections reflected a particularly radical aesthetic may have been the immediate source of the department's discontent. But if the juror had instead chosen work that matched another set of criteria, less radical perhaps but equally irrelevant to the content of each student's coursework, the result might not have caused as much faculty distress, but would have been just as impertinent.

It was clear to me that from the juror's perspective the work chosen for the show was selected precisely for its radical characteristics. Based on my own experience, first as an art student and later as an instructor, I had come to believe that iconoclastic or innovative aspects of a student's art work ought not to be the focus of an undergraduate art program. Though it may sound counterintuitive, I do not believe undergraduates are in art school to make art. They are in art school to learn the skills and gain the knowledge required by an artist to function as one in contemporary society. If a particular student piece happens to show extraordinary qualities similar to art considered ready for public exhibition, there is certainly no harm in bringing the attention of the class to that piece, or in initiating a discussion of its relevant values.

However, if an undergraduate program's primary goal is to encourage students to be original, or iconoclastic, or innovative, those

students may or may not succeed. But whether they succeed or fail will have little to do with any guidance that program offered. By following such a model, a university art department abdicates its teaching duties and embraces what is in fact a search for individual pieces of art that appear superficially like professional gallery entries. As I see it, the university's focus should be on the student and what they are learning from their student efforts, rather than judging what they produce as succeeding or failing in matching a fashionable look.

When it came time for me to speak at the faculty meeting following the student show disaster I read a long statement listing all the grievances I had heard from both students and faculty over a five year period. Using these as justification, I outlined a simple formula to replace the jury system: four pieces from each class, selected by the instructors themselves would constitute the exhibition, with no distinction between adjunct and full time instructors. Doing so would produce an exhibition of about two hundred and fifty pieces that would not only be logistically predictable, and therefore easier to install in a timely manner, but more importantly would create an exhibition comprised of a statistically meaningful cross-section of what the faculty valued in the work actually produced in their studio classes.

If there were pieces in the exhibition that raised cause for concern they could be discussed in their proper context as collaborations between instructor and student. Each submission would represent what the instructor defined as successful work within each course. All present at the meeting voted on the proposal and it passed easily. In doing so, we did not solve the entire problem, but we succeeded in disabusing ourselves of the notion that a randomly chosen professional would be in synch with the goals of each individual instructor.

The entire student exhibition episode confirmed an important aspect of my evolving attitude toward the department's curriculum and toward art education in general, in relation to the notion I had developed as a student that instructors are limited by the nature of

contemporary art in how much they can influence, or even how much they ought to influence a young artist's direction. The idea that art cannot be taught is more than a commonplace. It is the only sound basis for an undergraduate studio program. Students and instructors are not that far apart in their having to face an indifferent art world. Though instructors are loath to admit it, they navigate the labyrinth of galleries and museums on almost equal terms with their students. To make such an admission would reduce the distance between teacher and student, which is essential for that relationship to function.

To create a healthy, objective distance between the two that does not rely on an artificially defined hierarchy, undergraduate art students should be given the greatest freedom in their work; and by that I mean students should be free from the anxieties of the contemporary art market. They should be free from the pressures inherent in the ubiquitous and highly questionable art world enterprise of endless reinvention. A curriculum of foundation projects, within conventional parameters, measured with a clearly defined rubric will make for a more effective program. What students do with their skills after graduation, what they do as independent artists, even while in school, is their own concern.

My teaching of foundation level courses had by this time confirmed for me how the practice of rendering from nature ought to remain a significant component of any art program, regardless of what style individual students may embrace along the way. Not because rendering from nature has any inherent value as an approach to meaningful art (though I am personally inclined to believe it does) but because rendering from nature provides a standard for which progress in a student's visual sensitivity and articulation can be objectively measured, in order to demonstrate progress for both student and instructor. It has little to do with tradition. It has to do with measurable gains in a student's perceptive and manual abilities.

The emphasis on certain historical styles in relation to what we call traditional life drawing has been a source of confusion in this

regard. Think of the misplaced reverence for classical form that was so much a part of the stultifying academic tradition that required careful drawings of antique sculpture. To this day you find groups of students in the Greco-Roman galleries of the Metropolitan Museum of Art sketching from two thousand year old sculpture. Though it remains a useful exercise, how students understand the exercise is critical. If it is presented as a method by which students are expected to absorb the principles of classical form, then I would have to judge the sketching of antique sculpture a superficial waste of time. Even for art history students, how could an appreciation of classical form follow from laboring over unskilled renderings of it? Though making drawings could augment the study of style, both studio and art history students would learn more about style from written analysis and discussion. What Greco-Roman sculpture offers a student concentrating on drawing is a clarity of form that can be found in many other objects of less artistic import.

If an instructor explained to their students that they are to render these obviously beautiful images no differently than they would a pineapple, a frying pan or an engine block, the focus would be placed on each student's success in translating the optical to the graphic—precisely where it belongs. Accuracy and sensitivity to the nuance of pencil, charcoal or any medium used becomes the rubric by which the drawing can be judged—not as art, but as exercises in the use of drawing tools and their application toward an interpretation of perception. Drawings made in this manner would have the same relationship to art as push-ups have to the game of baseball. They are performed to build strength and to provide evidence of improved strength, which in art can be seen by comparing the drawn image to its source. The subject matter used in such drawing exercises is irrelevant.

As stimulating as my experience was in the college, and as complicated the issues could be surrounding the greater question of how best to teach young artists, my mind was equally occupied with the immediate concerns of my own painting. I was still an artist, and with

the birth of Melville's brother John in 1985, finding the time to make art was going to become an even greater challenge than it had been. Being a painter of urban environments and now the father of two I could no longer dedicate as much time to outdoor sketching as I once did. Though the light in my paintings remained a key element, I was compelled to rely on memory and a quick recording of atmospheric events, like cloud formations or the effect of light on a building facade. I found my memory could be relied upon in the recording of color and light, but drawing always took time, so I began using a small Polaroid camera to collect images.

Almost a toy, the mass-market Polaroid camera of the day had several key features that proved useful in the pursuit of my subjects. For one thing, the photos themselves required no processing. Finished images just rolled out of the camera. Until the advent of digital photography, this was an essential feature for someone like me with fair to middling photography skills and no patience for the inevitable delay between the perception of a scene and the processing of a print. With the Polaroid, if the picture was no good, I'd know right away and could take another. I could make notes regarding color and other incidental features based on my optical memory, while mentally registering them to aspects of the rather poor print the camera produced. The horrendous quality of the Polaroid print was its other useful feature. In terms of color accuracy it was consistently off the mark, distorted further by a lack of contrast. But these properties assured I would not be swayed by the synthetic color of the photographic process. What each photo provided was a general sense of the arrangement, the placement of shadows, and a few other guidelines for recreating the image in pencil that evening.

Use of the Polaroid allowed me to conduct a hit and run technique that fit adequately into a schedule that included working at the college, taking the kids to a park, or a museum, or helping with homework or other daily chores. And as using these washed out photos forced me to rely more on memory, the paintings became freer

in method but artificial in appearance. They evolved into a solitary looking style of picture making—a single tree, a lamp post, a fire in an empty oil drum—that made it difficult to expand compositions into more complex arrangements. To resist slipping back into a minimal aesthetic I made a determined effort to add complexity, and the best method seemed to be in combining smaller canvases into larger paintings of two or three panels, more or less the same multiple panel technique I had used in my geometric student work.

Working in south Brooklyn I had access to both urban and rural source material. Before we moved to Staten Island, my commute was along the Belt Parkway and Jamaica Bay, a stunningly beautiful landscape that would cause you to forget you were still within the limits of New York City. I could stop along the shoulder from time to time and collect images resembling traditional landscape that could be found along the shoreline. These would be combined with the more urban images I could find almost anywhere, to create the richness I was after. To facilitate this new working method, I chose canvas stretchers the same height, while varying the length of each. This way I could literally mix and match finished panels.

As I became comfortable with this working process it became possible now and then to plan entire paintings with a predetermined compositional structure. For example, I conceived the final imagery for a painting called *Time and Again*, before ever touching a pencil or camera. The center panel was to be a view from a beach out to sea below a luminous sky. The left and right panels were to depict an identical wall and clock in each, with the exact same time on the face of both clocks, but with different swaths of sunlight crossing each clock's face. The idea was to create a puzzle regarding time. How could a clock on a wall show the same time but reflect a different sun position? Another canvas, *Nightlight*, began as a drawing for a horizontal landscape, the viewpoint of which looked down the length of a beach at late evening, with a dark silhouette of trees at the right end of the frame. At this end I decided to add a smaller canvas that would suggest

the continuation of the tree line, while in the darkness below was to be the image of a night table, with a glass of water and a lamp. I hoped the effect of the beach section would be like that of a blanket pulled up over a bed, while the lamp might suggest a lighthouse on shore—with the two combined images functioning as interlocking metaphors.

I continued in the same manner for several years. Having short, daily sessions in the studio, instead of two extended sessions in a week, made it easier to maintain a productive schedule. I could work on as many as twelve panels at a time. The only drawback was that twelve panels only made four paintings. I was usually pleased with the quality of the work, but my level of output was very low. I never seemed to have enough finished work for a substantial exhibition. Follow ups to encouraging signals from galleries became difficult. By the time I had new work ready, parties who had shown interest had forgotten who I was. As a result, solo shows became rare. But as much as my time would allow, I kept to a schedule of group shows.

Seven

artists and the university

"Power—no word could be more inappropriate, more absurd, now, when we talk of art."

T.J. Clark

My peculiar job in the Kingsborough art department gave me a unique perspective on many aspects of the undergraduate enterprise. Independence from faculty politics put me in a position to hear unguarded opinions from every conceivable source; ordering supplies and equipment provided a widow onto how the curriculum was affected by the distribution of assets; and choosing studio equipment inevitably involved issues of syllabus design. In addition, the opportunity to teach provided crucial insights regarding the general problem of how a college adapts to goals that had once been the domain of professional art schools. From this odd perch (my official title and the one that appears on my tax returns is that of "laboratory technician") I could both participate in, as well as observe the whole operation down to the smallest detail, while remaining aloof from

internecine disputes that on very rare occasions would disturb our characteristically tranquil department.

But to be honest, the job's daily routine could get rather dull. It was the art gallery that afforded the greatest intellectual stimulation, both in relation to my developing ideas regarding art and the university, and to my personal orientation toward art and the teaching of young artists. Our exhibition record at Kingsborough could compete with any college gallery in the area, and our exhibitions would have been visited more often by people beyond the college community were it not for the ninety-minute subway trip from Union Square, which is an interminable commuting length for the typical New Yorker. But in spite of our limited art world exposure, we mounted exhibitions as if we were on Union Square. The whole point was to bring the art world to our students, so they could spend more time at each exhibition, while keeping to their class schedules and part-time jobs.

Lilly Wei, who is largely responsible for the reputation the gallery enjoys today, was not only the gallery director who set the standards that we held to all these years, but also served as slide librarian for an ever expanding art history section. It was a substantial work load, and when an opportunity to retire came along, she took it without hesitation, freeing herself to devote more time to writing gallery reviews and feature articles for a variety of art publications. When she announced her plans to leave I made a pitch to the new chairperson, Janice Farley and to then acting college President, Fred Malamet to approve my taking on all responsibility for the gallery. Both parties agreed, and once the last of Lilly's exhibitions closed I was made director with the responsibility of filling an exhibition calendar.

Becoming art gallery director extended my autonomy and increased my status, though the position did not include the elusive prize of faculty rank. I was never able to cross that line, as my Masters in Painting from Teachers College was sixteen credits less than the typical Master of Fine Arts, and so forever short of the department's requirements. As a situation of near comic absurdity, it often reminded

me of a routine British comedian Peter Cook would perform about a man who wanted to be a judge, but, "...didn't have the Latin...", and so ended up a coal miner. The class consciousness underlying his joke seemed a suitable parallel to the inflexibility of academic rank. Nevertheless, by the time I became gallery director the issue no longer mattered to me. The increased responsibility for what students were offered through the exhibition program, gave me a chance to participate more fully in the educational goals of the department, by coordinating the gallery program to the curriculum.

It is the nature of any curriculum to remain a work in progress. But a studio art curriculum offers additional problems. Establishing methods and goals becomes a particularly arduous task, as structuring courses to match the way artists actually develop is often impossible without chafing against fundamental principles of a degree system. For example, a recommendation that a student, whose drawings are poor, ought to take additional drawing classes becomes problematic, as progress in a degree system is not measured solely by the drawings themselves, but by how many credits in drawing that student had accumulated.

Admittedly, an instructor can always force a student to repeat a course by failing them. But artists, most of whom are part-time employees of the university, with few alternative job offers in the wings, are not likely to fail their students very often. Enrollment numbers for an instructor's class might slip, if a rumor spreads that students have been known to fail, placing that instructor's already tenuous employment in further jeopardy. If only a small number of students sign up for the course, it will be cancelled, and the instructor will then lose income that semester. The problem is not unique to art. But for obvious reasons medical students are rarely carried forward to certification with questionable abilities. I know it may sound histrionic—as if I'm warning against populating the countryside with dangerously bad artists—but this change in how student work is assessed serves to illustrate what a poor fit the visual arts made into a

degree system. Far more troubling however was when the university inflated the academic studio program by promoting the requirement of a terminal degree—the Master of Fine Arts—for all tenured college instructors.

MFA programs began proliferating in this country in the 1950s, just as the Abstract Expressionists were receiving long delayed recognition for their many years of unsupported effort. Among the members of that extraordinary group were those with high school diplomas only, like Jackson Pollock, those who attended traditional art schools instead of high school, like Willem de Kooning, and those who earned bachelor degrees in non-studio disciplines, notably Barnett Newman and Robert Motherwell. Almost none had MFAs. In fact, Motherwell was encouraged by Meyer Shapiro to abandon his graduate studies at Columbia in order to pursue a career as a painter. A mere twenty years later Shapiro's advice had become obsolete. To be a serious painter in the 1970s you were encouraged to get a forty-eight credit MFA. And as celebrated as they were, if Pollock, de Kooning, Newman or Motherwell wished to be named to an art department faculty as full-time tenured professors of painting, and if institutions were lucky enough to get them, they would have required waivers since they lacked the proper credentials.

What universities did with these programs was appropriate the normal period of development artists experience when they leave art school, and superimpose an academic veneer over it. Prior to the dominance of the MFA, this period of an artist' development normally lasted anywhere from a few years to a decade or more, and consisted of intense interaction between artists and those in their environment who care about art, that eventually settled into a steady and more independent learning process. If these programs only added grades and diplomas to an already established phase of an artist's life, their influence would be negligible. But in redefining the creative process into an academic endeavor, mentors for young artists who excelled in visual and manual acuity were gradually replaced with mentors who

fared better in a scholarly environment. The change was both subtle and moderate, and hardly devastating at first, but it opened the door to unforeseen influences.

Beside the unfortunate and rather obvious result of overemphasizing theoretical methodology in studio practice, a more insidious effect of the MFA was in its mismatching of creativity with a research environment. Forcing them together unwittingly gave commercial art market forces undue influence. Though it may seem as if artists were planted neatly into the collegiate landscape, alongside biologists and historians, in practice a full-time tenured painter on a university art faculty is chosen for that position in what can only be described as a parody of academic self-regulation.

For a candidate to achieve a tenured position in any academic discipline they are usually required to show evidence of having weathered peer review. To be awarded tenure as an historian, a candidate must have at least published a work of original research in a peer reviewed journal, meaning the candidate's research had been selected by a committee of historians serving on the editorial staff of a non-profit and professionally respected periodical. Upon publication, the candidate's work is further reviewed by the journal's readers, members of the profession who enjoy a standing invitation to either respond by letter (or in the greatest compliment to an author, respond in essay) to an aspect of the original article in that same, or in another peer reviewed publication. In short, evidence of having instigated an open, relevant conversation within the discipline, is required for awarding the responsibility of tenure to any individual.

For a painter to impress an academic tenure committee they must show evidence of having participated in exhibitions, particularly solo exhibitions, mounted by notable art galleries and subsequently reviewed in the art press. To do well in this crucial area, our painter must have first convinced a gallery owner to agree to represent him in the art market. The gallery owner, a self-appointed entrepreneur who answers primarily to his landlord, will decide to represent our painter

based on potential sales; meaning he will decide whether a stock broker, flush with a bonus check is likely to find one of our painter's canvases appealing enough to purchase. Once committed to the artist, the gallery owner will improve both his and the painter's chances for success by the distribution of a press release among possible reviewers. Circulated around art magazines, whose publishers favor shows in galleries that purchase advertising space, the press release will eventually reach the critics, who are themselves under pressure from fierce competition for their highly qualified, yet seriously underpaid jobs, to appear constructive and helpful. With luck, a critic will see the exhibit and respond in a written review, usually comprised of comments ranging safely between neutral and enthusiastic, depending we hope on how they actually feel.

And based on how well our painter candidate negotiates this commercial gauntlet, tenure committees make their hiring decisions, which in turn affect all aspects of what is to be required of students who come under the auspices of that program's curriculum. Clearly, the concept of academic peer review is not served well when a crucial component of a candidate's credentials depends on the collective judgment of competitive salesmen, impulsive collectors and intimidated critics. The art market is not the problem here. All markets tolerate some measure of irrationality. The problem is with a community of artists, huddled behind ivy walls, while unpredictable fashion trends dictate whether they get to stay behind those walls. The professional artist, enhanced by the power and prestige of a university, ought to stand as a bulwark against this sort of market influence, not as a model for successful collaboration.

My desire to become a teaching artist was now partially fulfilled, as the position of gallery director afforded a chance to assume a more substantial educational role within the department. One of the first things I did was to take steps toward assuring the gallery's independence by establishing an art gallery committee. Comprised of faculty members and gallery staff, the committee would review all

submissions and proposals for exhibitions, so as to keep the exhibition schedule relevant to the curriculum. The committee then eliminated any contractual relationships with exhibiting artists regarding sales. In all honesty, sales rarely occurred. But when they did, the bureaucratic protocol for accepting a percentage was hardly worth the time and effort. More importantly, however, we wished to keep the mission of the gallery unambiguous. According to the new rules, if a visitor wished to purchase a work of art in our gallery we would put them in contact with the artist and they would be free to make any arrangement satisfactory to both parties. By avoiding any commercial interest on the part of the college we could maintain a clearly defined mission based only on the cultural value of the work exhibited. With art in the clutches of an irrational market, it seemed the only sensible option.

Having installed an exhibition of Janine Coyne's photojournalist work from Sicily, which was a great show that literally fell into my lap, I had to rush to get the remaining calendar year booked. Following up on an idea I had carried around for some time, I contacted Deborah Brown, a painter with whom I had no connection, but whose mosaic murals in the Houston Street Subway Station I had always admired. My intention was to build an exhibition illustrating how a public art project is planned and executed. Responding with enthusiasm and energy, Deborah began immediately sending me copies of letters, contracts with fabricators and architectural elevations from the project. She then put me in touch with Sandra Bloodworth at the Metropolitan Transportation Authority, who loaned us many other documents, notably Deborah's original oil sketches, and with the people at Miotto Mosaics who had translated the artist's work from painted images to cut glass tesserae for the final mosaic. In the space of three weeks the whole thing was assembled and installed.

But of all the shows I've mounted since 2000 my favorite from an art educator's point of view was the political cartoon exhibition of November 2001. In late summer I emailed about twenty of the best known political cartoonists around the country and made the simple

request that they consider sending us one original cartoon for exhibition that would be immediately returned to them once the exhibition was over. I specifically wanted examples that revealed their technique. Optimistic by nature, I was nevertheless surprised and pleased when ten of them responded within a few days, many by just mailing in their work. The final list included Chip Bok, Jim Borgman, Jeff Danziger, Walter Handelsman, Rob Rogers, Mike Smith, Ed Sorel, Jeff Stahler, Ann Telnaes and Signe Wilkinson. I was particularly pleased when Telnaes responded, as she had just won a Pulitzer.

I am still impressed with how each artist responded so generously and gave their trust to the gallery with a minimum of fuss. Perhaps the fact that the show took place on the heels of 9-11, which was the overwhelming subject matter in the submitted cartoons, had something to do with it. Nevertheless, each cartoon was simply packed in a file folder and Fed-Ex'd to the gallery. With the modest expense of section frames and a few shipping bills we were able to give students the opportunity to demystify the work they saw printed in *Time* or *Newsweek* by allowing them a close-up view of the white-out blotches, scotch tape and pencil guidelines of the originals. Several of them reminded me of how I once admired a Picasso portrait of composer Igor Stravinsky I had come across as a student in an art history book. It was a continuous line drawing made without lifting pen from paper. However, seeing the original up close in a museum exhibit I discovered there was an elaborate and carefully constructed pencil drawing just barely visible that served as a guide for Picasso's unbroken line. Demystification can be just as important to an art student as exposure to feats of virtuosity.

In 2005 Regina Peruggi became our new college President and took an immediate interest in the gallery. By generously doubling our budget we could now print catalogs for each exhibition, which allowed us to approach artists and collectors that would likely have hesitated exhibiting in the hinterlands of south Brooklyn. As a painter, I understood their reluctance. The benefits of exhibiting in any specific

venue are universally understood as follows: either a large part of the visitor population will be art students, or collectors are likely to make acquisitions, or critics may review the exhibition, or a full color catalog is promised to accompany the show. We could now claim two out of four, which we felt should win over a few more prospects. The catalogs in particular were appealing, not only to the exhibitor, but to members of the department who could participate by writing an essay to accompany each exhibition. Students would benefit as well from the additional context.

I knew from personal experience how an artist weighs the pros and cons of exhibiting far from Manhattan's umbilical reassurance. From 1999 to 2007 I had been exhibiting my work at the Southern Vermont Arts Center in Manchester, Vermont every second year, mainly because I was offered a one-person show each time, but also because each exhibit produced a few sales. With two kids headed for college, selling paintings was a higher than usual priority. The only drawback was that by accepting their offer year after year I neglected opportunities to show closer to home. Being employed full time never prevented me from working in the studio, but my output was barely enough for a one person show every two years. Once my commitment to Vermont was met, I usually had little left over to show anywhere else. The one exception was when I made a special effort to respond to an invitation to show at the Kirkland Art Center in Clinton, NY, a few miles south of Utica. I immediately accepted upon learning that the curators at the nearby Munson Williams Proctor Museum of Art were regular visitors.

The work I was doing at this time was an effort to augment the multiple-panel format with additional materials like gold leaf, mahogany, beeswax, unprimed linen and elaborately constructed elements that had little to do with oil painting. Though none of the paintings I showed at Kirkland had figures, each painting was based on imagery associated with figures from Ancient Greek mythology. Among them was a painting called *Orpheus*, a narrow vertical canvas of

deep blue depicting a full moon over still water. On either side were unpainted hollow panels made of Honduran mahogany with a "sound hole" in each that revealed the gold wire used to hang the painting on the wall. The point at which the painting hung was directly behind the image of the moon, and the wire was secured on either side with tuning pegs from a cello. To my great surprise, the painting sold to a local collector, earning the art center a welcome commission, while covering all my traveling expenses to and from Utica.

Daedalus and *Icarus* were the two largest pieces in the series. *Daedalus* was a wood labyrinth, framed on either side with oil on linen panels depicting clouds. The clouds on the right opened in a shape implying a wing, and the left panel was its mirror opposite. *Icarus* was of identical dimensions, with the right and left panels repeating the wing shapes used in *Daedalus*, but painted in encaustic on wood panels to represent the wax element of the father's faulty design. The center panel of *Icarus* was of unprimed linen that had been bleached in the sun to reveal the shadow of a stencil made in the exact dimensions of the labyrinth.

When Susan and I drove up five hours in the snow to retrieve the remaining work at the show's end, we were given the great news that Munson-Williams curator Mary Murray liked these two very much and asked if I would agree to give one to the museum, an offer I immediately accepted. For myself and I assume for the vast majority of painters, making a sale will always run a distant second to getting a piece accepted into an important public collection. My only regret was having a painting in a major collection that looked nothing like the paintings I had been working on most of my career. As conceived, it was a genuinely successful piece. Yet I could not help but notice that its painted elements were to me the least impressive aspects of its design. It brought home the realization that I had somehow managed, in my long search for complexity, to drift from painting itself.

And as it turned out, this realization came at a moment when I had become exhausted from ideas. I was literally tired of thinking. I no

longer wished to plan, design or construct. I wanted only to paint; to work in a purely intuitive mode. So I decided to put the multiple-panel format behind me, and simplify. I was of a mind reminiscent of my last days as a sculptor, when I felt the need to break loose from constraints that were inhibiting my creative energy. This time, the urge was to break free from what seemed like interference from my chosen subject matter.

The separation between the mythical subjects, and the actual business of visualizing them, had become so complete I no longer felt it was painting at all. My desire to get back to the simple act of applying color to a flat surface became visceral. It expressed itself as an energy not unlike that of water seeking a path of least resistance. In fact water is a particularly apt metaphor, for in its purest form, painting can be as liberating to an artist as swimming can be to an athlete. Both entail gliding, easy movement and a synchronization of thought and gesture. There had been little synchronization in the mythological paintings because thought and gesture had grown apart. I was now determined to reintroduce my hand to my eye, and to make this reconnection I began what turned out to be a three year period devoted to still-life painting.

As my narrative closes in on the decision to paint portraits alluded to in this book's introduction, and as proximity to that end presents the opportunity to reassess my thinking regarding that decision, it now strikes me as odd that I did not see more clearly at the time what was happening. Though each piece in the myth series illustrated a story element, it could be argued that each piece was also fundamentally figurative. In a sense I was already dealing with the figure as a subject. Perhaps if I had been more cognizant of this, and less distracted with the discomfort of having strayed from the essence of painting, I could have made the jump to portraits right then and there. But as with every new turn in the road, instinct, not practicality, usually points the way. First, you know what you have to do, and only later can you interpret the meaning of what you have done.

Moreover, there seems to be a secret logic at work when following one's instinct, for without painting still-life images for three years, I doubt I could have developed the chops or the confidence to take on a subject as demanding as the figure, let alone portraits. Intuitive thinking is always the better method for an artist, which is why I find it counterproductive that graduate studio programs encourage artists to theorize about their work as they create it. From my experience, too much written analysis diminishes instinct and can lead to weak visual presentations that fall short of the quality needed to keep up with ideas that seem to flow so easily in theory. To explain what you are doing, while you are doing it, is the opposite of how most artists actually conduct themselves in their studios. I prefer the example offered by British artists Gilbert and George, who state unequivocally, "We don't know what we're doing. We think it's better not to know."

Still-life is the genre best suited for developing discipline as a painter. It requires little intellectual preparation, the expense of a few peaches is negligible, and there is peace of mind in knowing your grapefruits will never complain their legs have fallen asleep. For me at the time, still-life was about the silent business of color, form and composition. But I worried too that bowls of fruit could become the sin qua non of banality. Nevertheless, I thought, if a still-life painting could compel a viewer to devote several minutes of study to it, the credit would go appropriately to the painter for how the picture was executed, as most people find little mesmerizing power in a tablecloth. Being a straightforward visual exercise, at least on the surface, it is no accident that still-life is the genre of choice among painting instructors. It keeps the anxiety of subject matter at bay, which is exactly what I felt I needed at the time.

My approach to still-life had some continuity with my earlier landscape painting in that I thought it essential when arranging a motif to rely on natural light from a window. Since the beginning of my commitment to representational painting I have been dedicated to the painting of light. Light was what drew me to landscape painting. I find

it inconceivable to make any decisions related to color without the knowledge of how color behaves in natural light. Using an artificial light source, which I experimented with for practical reasons with some of the early still life pieces, will inevitably appear as such in the final work. Lucien Freud is one of my favorite painters, but much of his late work is inseparable from the color range of an incandescent lamp. I'm more at home with the natural indoor light of Fairfield Porter's work.

To make the light itself an integral part of the painting, I often chose moments early in the morning or evening when the sun came directly through a window, casting a patch of light across the motif. These moments would pass in minutes and so I had to make use of photographs to get the shadows accurate. But the photographs were ineffective in capturing anything beyond the simple contrast of light and shadow on a surface. For rendering color's subtlety, photography is all but useless. This is where memory comes in. Even if you work from a motif directly in front of you, the second you turn your eyes to the canvas, your memory of the color becomes your only reliable tool. To understand the difference in color between a patch of sunlight on a wall, and the color of the same wall just to the right of that patch of sunlight, is a fascinating and demanding optical problem that cannot be solved with the use of film, because to perceive the difference in color is to interpret many instantaneous and decidedly human optical adjustments a camera cannot perform. Edward Hopper once said he'd be happy just painting sunlight on a wall. I know exactly what he meant.

Eight

artists and the exhibition space

"Is the private life, the deepest self, unconnected with public performance, both of them sealed off from each other, alternate masks one puts over one's face?"

Garry Wills

 I no longer remember why I was drawn to gallery work, but I have been installing exhibitions since art school. Perhaps it was a natural path for someone forever preoccupied with how things work. Even during my stint as a musician I had become involved in renovating and modifying electric guitars. But just as form is incomplete without content, so the technical aspects of hanging paintings and securing sculpture, inevitably led to the social mechanics at work in an exhibition space. I began to understand the gallery as a threshold through which art crosses from the artist's mind to the shared experience of viewers.

 A gallery position provides a unique perspective from which you can observe artists crossing this threshold, even more so if the gallery is committed to assisting and supporting the vision of the exhibiting artist

beyond merely facilitating a neat installation. As a college gallery with no commercial interests complicating our efforts, we made it our business to be each artist's advocate. By working closely with artists as they wrestled with the difficulties of bringing their vision to a public forum, and seeing first-hand how restraints of space, materials and occasionally simple physics could alter what they had conceived in their studio, provided invaluable insight regarding many precepts that tend to linger unchallenged in the minds of contemporary artists.

On rare occasions the struggle between an artist's vision and that vision's realization could prove insurmountable, as in this one incident at the gallery that highlighted for me the arduous path an artist takes in applying a greater significance to the virtue of pushing the envelope than that perennially vague ambition ever deserved. Back when I was the gallery assistant, a painter with an extreme minimal sensibility responded to an invitation to exhibit at Kingsborough with a group of small panels and one very large canvas. As best I can recall, he decided the day of installation that he didn't like the way the smaller paintings looked in the space, and decided he would only show the large piece on the one large white plaster wall that marked the west side of the gallery. It was an eccentric decision, but we were there to serve his vision, not judge it.

This large canvas, that was now to constitute the entire show, was about eight by twelve feet, perhaps larger, comprised of raw cotton canvas with a small mark in paint somewhere near the center. The color of the mark was intentionally similar to the color of the canvas, and as such took a viewer some time to notice it was there. Dissatisfied with how the canvas looked on the wall, the artist asked us to move the lights around, which took considerable time because each had to be removed from its connection eighteen feet off the floor and repositioned, moving the mechanical lift twice in each instance. Still dissatisfied, he requested more lights. Several hours later, we had as many lights on this single canvas that the circuits could manage, and yet

he was still not satisfied. He then requested that we turn all lights away from the canvas.

Whether he was trying for an indirect lighting effect was not clear. It seemed such an extreme request, as it ended up training the lights into the eyes of onlookers, leaving the painting in a dimly lit background. He then asked us to turn about half the lights off, which meant taking each one down from the ceiling as they could not be switched on and off separately. But apparently that also failed to produce the appearance he had in mind, so at his request we turned all the lights off. Still not happy, he asked us to take the painting down and rest it on the floor, leaning against the wall. Not caring much for that either, he now wanted it propped up on a low platform of sorts. Regrettably, all we had of the proper height were several drip-covered paint cans. Whether he gave up on his ability to realize his plans, or on our ability to accommodate his requirements, was never resolved. But he left that evening, noticeably frustrated. At the exhibition opening the following day, it was up to the gallery staff to discuss as best we could with students what they might take away from a seemingly blank canvas sitting on paint cans in the dark.

As the host institution we had assumed an obligation to help the artist as much as possible in creating an appropriate environment for his work. But there is a collaborative aspect to any exhibition, and as in all collaboration there must be an equal investment of ownership. If we could not meet the artist's requirements it was his prerogative, indeed his responsibility, to cancel the show. And had he taken that route I would have felt more respect for his dedication to an apparently difficult concept. As a former student of minimal abstraction I had some empathy for his predicament. But I felt his decision to simply walk away, leaving an unresolved installation for our student viewers seemed to imply the exhibition's shortcomings were the fault of the gallery.

If I've convinced the reader thus far that art exists primarily as a public conversation, then perhaps my relating the above incident will

help support my contention that an artist's internally directed method of working can become so narrow that it resists sharing much of anything with the viewer. This obsession with doubling down on a radical position can be traced directly back to accepting as indisputable the assertion that an object becomes art by fiat. In principle it stands impishly confident. In practice it places too much attention on an artist's motivation, which can lead to work that not only fails to visually live up to its ideological precepts, but often deteriorates to a visual footnote in support of the idea. There is no disputing that this can be done. Whether art made in this spirit is likely to engender a substantive conversation is another matter. Unfortunately, we in the art world have become used to encountering art like this—art that closes rather than opens dialogue. When I was a student I once heard a critic confess to reviewing a Sol Lewitt exhibition without even visiting the gallery. Why bother? Everyone knew what a Sol Lewitt exhibit was going to look like. Though vital to the creative process, ambiguity and poetic license, when taken to extremes, create a predictable distance between artists and their intended audience so wide that conversation lapses into soliloquy. Absolute freedom for the artist implies that alternative viewpoints are beside the point. There is no discussion required in an art of decree.

The freedom artists enjoy today was hard won over many centuries. Contemporary artists are the beneficiaries of progress made from Veronese's withering defense before the Inquisition in the 1570s, to the wholesale acceptance of Jackson Pollock's boasting of coequal status with nature, four centuries later. Artists are clearly more comfortable in today's freer atmosphere, but freedom is only one aspect of an artist's method. A strictly linear reading of art history creates the illusion that progress can be measured by artistic freedom alone, when in fact it runs parallel to both the tenuous social position artists continue to occupy, and to the increasingly lopsided dialectic between art and audience. When in his saner years Ezra Pound warned, "Never accept anything as dogma", he was not just speaking to artists,

but to everyone in the conversation, including the audience. It is certainly possible to produce a work of art that has meaning only for the artist, with little hope of it ever communicating anything beyond the fact of its existence. But where is the value in that?

Consider how the two critics quoted below addressed the difficulties of Jackson Pollock's all-over drip paintings of the early 1950s:

"Jackson Pollock's problem has never been one of authenticity; rather, it is to find the means to cope with the literalness of his emotion, which is of a kind that seems foreign at first to pictorial art. And though he may over power his means at times, he rarely falsifies them; he may turn out bad pictures, but they are hardly ever unfelt ones." Clement Greenberg, 1952.

"Art like Pollock's is a means of withdrawing from one's times, of having only a reproachful relation with them. A poured painting offers us the spectacle of a will manifesting its isolation, first to itself and then to its audience." Carter Ratcliff, 1996.

Though each writer recognizes Pollock's sincerity, both choose to point out that the drip paintings are about Jackson Pollock, and provide very little room for dialogue concerning anything or anyone else. Greenberg, from a contemporary perspective left open the question raised by the work's difficulty. With Pollock ensconced in art history forty years later, Ratcliff was comfortable offering a more conclusive opinion. But aside from each critic's conclusions, whether stated or implied, both comments illustrate how Pollock's drip paintings pushed the argument for abstract painting so far into a corner, that the meaning of these still strange canvases remains today as controversial as when they were first shown, if only one takes the time to consider them as paintings and not simply as icons of unquestioned importance.

It seems to me Pollock's real influence on artists has not been specific to painting, but to the unfortunately popular notion that an artist's motivations, if perceived as sincere, will be enough to carry the burden of meaning. Pollock has earned a unique place in art history,

but I think his work from 1943 to 1948 better represents his achievement. The drip paintings, for all their cultural status, have only encouraged narcissism, ideological rigidity and more than a few troublesome forgeries.

In hundreds of repetitions during my time working in the gallery, I have hung a canvas on the wall, stepped back several yards, and turned to examine the results. I've also performed the same ritual innumerable times in my own studio, and in both instances the few steps I take away from a canvas are essentially steps taken out of the private, and into the public realm. The function of this ritual in a gallery is obvious and requires no further comment. But in the studio, where the work is still open to change, it suggests a dual role for the artist. Painting is private in nature, while critical assessment is public. When I step back from a painting in my studio, I am assuming a public role by distancing myself from the intimacy of the work space, choosing at that moment to occupy a more objective stance. I am, in effect, standing in for the viewer. As a painter I fail to see how adjusting the finished work should not include some level of consideration for that viewer.

Because artists are both creators and viewers, both perspectives require their attention. If an artist fails to consider the public demeanor of a work, and leaves the viewer to struggle entirely on their own with an exclusively private and inner directed image, that artist may claim a purity of vision, but an interested public cannot be faulted in finding the work unintelligible, if not obtuse. More to the point, I feel the problem is not ambiguity per se, but the difficulty created by an artist taking a stingy attitude toward the viewer side of the equation. This was the basic lesson I learned from my student experience with minimalist ideas. Once I rediscovered rewards of complexity and shared subject matter, I began to appreciate the pared-down vocabulary of modernism as a starting point, or pivot—not an endgame.

That contemporary artists continue to assume the public will eventually come to understand extremely difficult work, suggests they have come to believe the process to be inevitable. They take for

granted that their own understanding of the work, which could be quite narrow, is destined to travel by some avant-garde osmosis into the public imagination. Therefore, to expedite this transfer of meaning, exhibiting artists often provide a bit of writing—an artist statement—to accompany their work. When reading these statements, I am struck by how often they begin explaining the artist's interest in a particular theme or subject, which is a statement's most enlightening aspect, but soon switch to interpreting the work for the public in a voice better suited to a docent or critic.

Originally meant to offer guidance in establishing context that could assist a viewer in appreciating the final work, the artist statement has become a crutch many artists rely on to assure the viewer ends up with an interpretation that does not stray too far from their own. This abuse of the statement interferes with a viewer's participation in the conversation by preempting or nullifying what would have been their instinctive response to the work's appearance. If an artist is to be the only trusted interpreter of their work, if the public is expected to accept in almost contractual terms the artist's explanation of their visual presentation, what function does the art itself serve in a public forum?

I accept that artists are defined by the control they have over their work. But excessive control of their work's interpretation is incompatible with the notion of sharing the work with the public. I have been a lifelong admirer of Samuel Beckett, and yet I have never been comfortable with his attempts, late in his career, to control the production of his plays down to the smallest detail. His words should be left as written, just as the words of any playwright ought not to be subjected to editing or rewriting by directors or performers. But Beckett's attempts in his productions, aside from his mime pieces, to describe the length of footsteps, or the angle of arm gestures, ought to be considered suggestions, not rules. His work offers particularly fertile ground for cross cultural interpretation. For that reason alone, I cannot help but feel his attempt to maintain maximum control over the staging of his plays was misguided.

In general, I find it disconcerting how artists—having freed themselves from the shackles of official control that had restrained their work for centuries—began themselves assuming despotic tendencies once free to do so. In a strange cultural reversal, just as Beckett took an unseemly level of control over his actor's interpretation of their given roles, so visual artists today routinely maintain control of their work's interpretation by an over reliance on context and the written word. The fact that so many works of contemporary art are presented behind a screen of written extrapolation provided by the artist, suggests an unwarranted confidence in ideas over appearances.

From what I have seen in much recent art, this tendency to rely on explanation, rather than the visual appearance of the work, has produced the unintended effect of dividing appearance from meaning. And because many artists now seem to accept this as a norm, as they have learned to rely on content that can be plugged into the work, without truly integrating it into each piece's unique visual language, they unwittingly diminish the visual significance of their art, making it easier for the sales people and marketing experts to define each new work as another *piece* of art, a small portion sliced off a homogenous inventory of marketable culture, rather than a unique expression meant to connect the viewer with the artist on a personal, human level.

In my own work, particularly in the mythological paintings, the text put such limitations on the visual expression of each piece that the painting aspects became secondary. I came to see that I could have outsourced the actual painting to a competent illustrator. It no longer mattered how I painted them, as long as they conformed to the subject. Turning to still life solved this problem temporarily, but still life painting simply reversed the imbalance. After about sixteen months, the content of the still life paintings began to seem dull and ordinary. What I needed was a subject that was rich and challenging in both content and form. But I didn't have one, and so I ended up in that dreaded, anxiety-ridden purgatory of the mind, where artists sit—idle

helpless and brooding—waiting for inspiration. Nothing was going to happen without the cooperation of the muses.

The flow must continue. It's why they call any interruption a block; a dry spell. And the discomfort an artist experiences when this happens is exacerbated further by an awareness of how easily that same flow seems to rush along for those fortunate enough to be in its current. Watching inspiration unfold in another makes it seem effortless. When our children were small I was fascinated by how making art came so easy to them, and I'm sure we're no different than other parents in that Susan and I have kept boxes of their creations. Looking them over recently, reminded me of an afternoon when Melville, who was about five at the time, expressed a desire to paint in my studio. I draped her in one of my studio tee shirts, which made for an almost floor length smock with Louise Nevelson sleeves, and I pinned ten sheets of paper to the easel. Brush in hand, and colors arranged, she began painting in what could only be described as pure, spontaneous energy. What I had planned as an hour's activity raced along at such a pace that I barely had time to tear off each finished composition before the next was begun. She produced thirty or so, each one utterly different.

I often took both John and Melville to the college, and on one particular afternoon, having exhausted his interest in academic corridor golf, I placed John in the hands of Trish Early, an artist on the teaching staff who offered to bring him over to the ceramic studio for an hour or so. John was about seven at the time and I was sure he would produce a bowl, or a cup that could be fired and kept for posterity. Several hours later Trish called me over to the studio to have a look. Having watched a demonstration of slab rolling, John had set upon a project to build a castle. In short order he produced one structure about twelve inches high and twice as wide, consisting of walls, towers, battlements, winding staircases, small windows, incised gates and an army of both living and vanquished defenders scattered all over the

interior courtyard. He also produced a second structure of the same theme and details, but of an entirely different shape.

To watch children make art, which is one of the great joys of being a parent, is to be reminded of how they are the opposite of controlling, fussy adults. They go at it single mindedly, with no apparent lapse between thought and action. Melville's paintings were vibrant and rich in variety and texture, and full of the extraordinary intricacies only paint can produce. John's work was gestural, in a manner commensurate with the size of his hands, while easily maintaining a true architectural coherence.

Both displayed a strong visual intelligence that harmonized with their enthusiasm. When children reach adolescence they become self-conscious, as thoughts and actions are weighed against the repercussions of living in a more complex social environment. Inevitably, they lose much of that playful enthusiasm. Artists tend to retain it. In fact artists are not unique in this regard. Anyone gifted in the art of living has most likely retained a similar connection to the impulses of their early years. But it is considerably more prevalent among creative people. As important as theory, critical analysis, or history may be to an artist, an instinctive drive to create is indispensable. But professional artists are not children, and if their aim is to participate in the conversation, a basic respect for the viewer ought to be honored on some level during the creative process—which was the issue I faced once I became inspired to paint figures.

Making the jump from still life to figures was an obvious step toward the relevance I had been seeking all my professional life. And having made the choice, I could interpret my decision as an attempt to reconnect to earlier work, picking up so to speak from where the mythological paintings had left off. But to claim such conscious motivation would misrepresent what actually happened. Frankly, the notion to paint figures came to me through the same portal from which all inspiration seems to arrive. It simply presented itself with no warning as a new path to follow. Only after many months of

enthusiastically following its lead, did I begin to appreciate *Daedalus* and *Icarus* as precursors to the portrait project. Only after many months—and a long look backwards—did the new portraits seem as links in a long chain.

Now committed to the figure, my initial plan was to paint portraits of fictional characters, not necessarily based on literary sources, but drawn from archetypes I could develop intuitively as each canvas progressed. What I had in mind was the confrontational model of de Kooning and his *Woman* paintings of the early 1950s. Though I had no intention of delving into Freudian angst, I liked the idea that each canvas would look back at me as I worked on it, challenging and defying my attempts to bend its appearance to my will. There are several photos of de Kooning, shot in a cinematic over-the-shoulder perspective, standing at a distance from one of his figure paintings that emphasize this adversarial relationship between artist and image. Those photos were the inspiration for the cover design of this book.

I imagined I would place myself in a similarly confrontational stance. But in practice it turned out to be more like an encounter than a confrontation. As I made more and more studies in preparation for the technical challenges intrinsic to the project, I came to appreciate how a portrait of anyone offered the same potential for encounter. Working from news photographs and reproductions of old paintings, I became completely taken by the unique and poignant properties that could be brought to a depiction of a human being on canvas. And so I dropped the fictional character idea, and committed my efforts to portraits of living persons.

This changed everything. Even walking through the Metropolitan Museum of Art, as I had done hundreds of times before, now took on a new sense of discovery as I became acutely aware of images that looked back at me. From the long hall of ancient Greek sculpture, through the nineteenth-century painting rooms above, eyes suddenly appeared everywhere. I had strolled through these galleries

since my student days, and yet suddenly I was feeling a stronger connection to faces I had thought I was familiar with.

Historically ubiquitous, the figure is a subject that appears at one time or another within every ethnic and cultural territory and thrives in both elite and vernacular environments. What the portrait offers is content, uniquely capable of standing on its own. It is the perfect subject matter, in that no extraneous context is ever required. And in terms of longitudinal relevance, portraits have multiple lives: as a depiction of a person I've known, as a depiction of a person others have known, and ultimately as a depiction of a stranger each viewer engages through the painting, with little or no knowledge of the sitter's history. What ties all these encounters together is human empathy, which will remain vital in each canvas, provided I manage to recreate some essential aspect of the sitter's individuality.

In other words, each sitter constitutes a thoroughly unique subject that is also capable of interpretation as a universal theme. The context each individual's appearance brings to a painted portrait is at least enough for me to establish a foundation for meaning, provided I avoid complicating the interaction between viewer and subject with artificial barriers. Having the sitter look directly at the viewer avoids those unfortunate connotations of allegory and formalism I dislike the most. As a method, it is very much the opposite of the film director's warning to an actor not to look directly into the camera. I insist my sitters look directly at the viewer. For me, Illya Repin's portrait of *Vsevolod Garshin* in the Metropolitan Museum of Art is so much more engaging than Manet's portrait of *Èmile Zola* in the Musée d'Orsay, precisely because Garshin's gaze toward the viewer is so direct. Both portraits represent writers; people whose lives were dedicated to engaging their audience. But Manet's Zola does not engage. Though it is a great modern painting, precisely because it reduces the figure to a formal element, I no longer respond automatically to such formalism. I now find it unfortunate that the author stares off to the edge of the

frame, leaving the viewer with an image of Èmile Zola posing artificially as the famous writer, Èmile Zola.

Though a common feature in many portrait paintings, a sitter looking away from the viewer undermines what I believe is a narrowly defined space in which contemporary portraiture can still function. It's very much a personal opinion, but an opinion I arrived at intuitively, and so I have a great deal of confidence in it. I've actually felt this way for many years, long before I attempted portraits myself. For example, there is a painting by Joshua Reynolds of the actor Sarah Siddons, posing as *The Tragic Muse,* that I came across years ago as a student. Mrs. Siddons was known and admired by her eighteenth-century contemporaries for portraying pathetic figures on the stage. The fact that her life had been a series of tragedies, including a failed marriage and the deaths of several children, must have given her performances a singular contextual edge.

But Reynolds' painting of Sarah's performance struck this late twentieth-century art student as preposterous. Even today, I take full responsibility for what I know is a callous response to the painting. A small pang of guilt still accompanies my finding the picture hilarious. Apparently the obstacle is my very contemporary inability to believe in a visual allegory. My sensibility gets tangled in the painting's artificial components. They interfere with my relating to poor Sarah Siddons, staring off into the darkness of stage left. All I can see is the anachronism of both symbolism and bygone theater convention. When allegory still had power over the public, Reynolds was free to paint a performance, as well as a person. But today this extra layer of context has the unfortunate effect of creating two disruptive thresholds I must overcome in any attempt to encounter the subject that interests me, which is Sarah herself.

Repin's portrait of Garshin also relies to some degree on the context of tragedy. The portrayed writer's life was scarred by suicides in his family and culminated in his taking his own life at age twenty-nine. This biographical context certainly adds an emotional dimension to the

near hysterical stare the writer offers us on canvas. But knowledge of Garshin's history is not crucial to an appreciation of its power as an image, because the stare Repin succeeded in capturing so well, conveys to the viewer all that is required to feel the intensity of the subject's inner demons, regardless of whether those demons have been enumerated. To be fair, Repin was not engaged in allegory, but the comparison illustrates an aspect of the contemporary portrait that I believe still offers viable opportunities for painters.

Paint is the perfect medium for portraits. It is both fluent and unpredictable. It can never be truly mastered outside strict conventional methodologies, which when applied, tend to stylize the result. Like a disciplined Chinese calligrapher, a painter can choose to master specific gestures and strokes. But a portrait that depends on such formulaic solutions will appear to do so, and will suffer as a result. If they choose to do so, painters may rely instead on pure spontaneity, in effect reinventing their technique with each subject. But this can lead to a mannerism that ends up revealing too much about the artist and not enough about the subject. As a portrait painter I prefer to rely on the sitter's likeness as an anchor to keep the image from drifting. The painting will always be mine, and will always reflect my hand and my sensibility as an artist. So I feel confident my serving the likeness of the sitter will produce a picture that will be enhanced, not depleted, by any expressive imperfections or mannerisms.

Though not as prevalent as it was decades ago, there remains, among some representational painters, and among critics who care about such painting, a bias favoring the direct painting of a sitter at all stages of the work, as opposed to the use of the photo or other applications of an optical lens. Artists often express a partial faith in this bias by a reluctance to admit using photos. When an admission proves unavoidable, as is often the case in a magazine interview, artists tend to minimize their reliance on photos, as if they were admitting to a misdemeanor. The self-conscious tone is unmistakable. The bias against the use of photos is itself based on yet another bias, namely the

interpretation of painterly gesture as more expressive of an artist's feelings. I have no argument with those who assign expressive value to painterly gestures, nor do I have any argument with the mechanical aspect of many photographs. But painterly gestures can be faked, and even though photographs can often seem apathetic, they are rarely so in the hands of a gifted artist.

If any controversy lingers over these issues, it is a relic of outdated academic certainties. Though I too find some paintings suffer from an unfortunate dependence on the language of photography, particularly in terms of lighting, I can only judge a painting's worth upon seeing the finished canvas. I don't care how it was done, the result is what matters. It might interest readers to know that there are several Cézannes that have been found to be based on photographs. In the end, both painters and photographers are concerned with picture making. There are, however, many pitfalls a painter must avoid in the use of photos. The extreme of photo realism—a mechanical copying of the photo's intricacy—is as dead to me as color field painting. But I find arbitrary gestures and self-conscious expressionism equally feeble.

Representational paintings and photographs rely on variant dialects of the same root pictorial language. I choose to work with painting's unique qualities, and I prefer those qualities in the final work to those that might cause the painting to resemble a photograph. Most of the dangers can be avoided by simply taking your own photos and composing them in terms of what is needed for a painting. But I have learned also to be aware of excesses in paint handling. John Singer Sargent's sense of bravura added a vitality to his work, whereas Giovanni Boldini's produced a shallow artifice that aged badly. What a painter can express through paint handling is as varied as color itself. The painterly attitude does not require showing off. Its attributes can be both grand and subtle. They are not limited to the panache of a Frans Hals or a Joaquin Sorolla, both of whom I admire tremendously. Rembrandt's painterly touch, particularly in his later work, is methodical and cumulative. Van Gogh's touch is bold in color while

almost childishly cautious in application. But both rely on the physical properties of paint and the traces of its application to reach their desired results.

What makes a portrait convincing and compelling cannot be tied to any specific level of painterliness. A late Thomas Eakins portrait is as expressive in its own manner as the work of Egon Schiele. And in my estimation Eakins' late work is more expressive of the depicted individual than Schiele canvases, which tell us more about the artist's milieu, than about the sitter as an individual. In fact, I've learned from painters like Eakins the value of losing part of my ego in the service of the sitter. I believe Alice Neel's, *Hartley, 1965* is an example of great modern portrait painting, whereas Neel's *Fuller Brush Man* of the same year is more like a caricature; too much Alice, not enough Fuller Brush Man. Neel's aggrandized reputation for an uncompromising attitude goes a long way in explaining why there are very few moments of genius in her wildly uneven body of work.

Once a painter accepts that the finished canvas is the goal, how a painter gets there is only relevant if a particular method reads as an integral part of the finished picture. To get what I'm after, I have come to rely on two strong properties in my portraits. First, I must get as close to the sitter's actual appearance in the final canvas as I can, so as to produce a portrait as truly compelling to the viewer as the sitter's appearance was to me. I don't know of any other way of accomplishing this than to rely on likeness. Second, I wish to capture an aspect of a sitter's countenance that reveals the most about their individuality. To do so, I avoid the distracting interference of overtly conventional posing. My portraits begin with getting the sitter to relax. A relaxed sitter can be persuaded to avoid posing. This is important, because the language of painting and photography both contain standard poses sitters seem to know from experience. With patience, a pose characteristic of the sitter's individuality will inevitably avail itself. Even if the final pose shares some similarity with a conventional one, any residual artificiality will be diminished.

Each step in the process is designed to assure that the final painting triggers a meaningful connection between the subject and the viewer. The link between sitter and viewer is the key to everything. I want the viewer to feel the sitter looking at them. How my own sensibility is conveyed in each portrait, how the private aspect of my studio experience, and my own grasp of art history comes through in a finished work of art, is not something I can control very much, nor is it something I am necessarily aware of while I'm working. My primary concern in the studio is to get what I see and feel in the sitter's appearance onto the canvas in a form I can confirm when I stand back to study the result. All else is the mysterious residue of the art so aptly characterized by James Rosenquist as, "…minerals mixed in oil, shmeered on cloth, with the hair from the back of a pig's ear."

Epilogue

Since the moment I embraced the higher purpose of fine art, I have never felt the need to revisit the decision. I still see art as a noble undertaking. Dedicating one's life to standards set by artists who came before, while remaining true to contentions imposed by the time and place of one's birth, is as purposeful a life as I can imagine for myself. Dropping my original art school plans of becoming a record cover illustrator, in order to pursue a career in fine art, was not a difficult choice to make. Noting how the artists I met went about their work made it easy for me to distinguish between art made for selling things and art made for more substantive contemplation. Perhaps my early religious education had an influence on this decision as well. But whether or not my attraction to the contemplative was rooted in my upbringing is a topic for another book. Given the fact that art as a fundamentally humanist pursuit had been at the center of my studio work, and given that I came to understand that art was essentially a conversation with those who come in contact with it, it is no wonder I had difficulty finding subject matter that could integrate my abilities

with my wish to communicate. What kept me going most of the time was not only my sense of purpose, but an irresistible urge to follow this purpose.

Looking back I feel this urge was just as important as my reliance on intuition. In fact it is not easy to separate the two. Together they explain why music seemed more important to me after high school than some rather obvious practical matters. They explain why I found the ascetic ambiance of Minimalism so seductive, and why I later rejected that same asceticism. They explain why I refused to return to geometric painting, when doing so might have led to an early exhibition opportunity. They only partly explain why I chose to get a teaching degree instead of an MFA that could have led to a more lucrative academic career. The other part of that particular decision was pure naïveté, but a naïveté grounded in a commitment to art and to teaching as I understood them from the perspective of an artist, not an academic. And they explain why I currently paint portraits in an art world that celebrates the public relation stunts of Damien Hirst and Jeff Koons. To admit the obvious—that I have a tendency to be stubborn—illuminates only the contentious aspect of my choices. What I chose to contend with speaks to the larger subject of what is at stake in my own work, and in the work of all contemporary artists who are committed to an art of shared, substantive meaning.

In the months following graduation from art school, while I slowly gravitated back to the basic conventions of painting, my inquiry of art's nature and purpose continued in earnest, but as a search for what and how to paint, not whether to paint. In one of Joseph Kosuth's key statements on conceptual art, he argued in effect that to be a contemporary artist was to question the nature of art; but to be a painter was to dodge the question. By the time I left art school I was convinced that his conclusion was based on too narrow a role for the artist. To equate the choice of painting with an avoidance of meaning, is to misunderstand the nature of both. Art is not exclusively intellectual any more than it is exclusively intuitive. The idea of painting

is not where the art of it lies. The consideration of art by both artists and viewers is where art has always been, and will remain. The nature of art cannot be resolved any more than human expression can be completed. It is an open-ended process.

If you accept the premise that art is a continuous conversation, it follows that no medium can be dismissed. The idea that artists can extend the definition of what art can be, has been demonstrated over and over this past half century. Visual art has become an all-inclusive category of unprecedented complexity, defined through a plethora of new media. But the notion, implied incessantly by the exhibition schedules of contemporary art institutions like the Museum of Modern Art, the Whitney Museum and the New Museum, that new media have replaced older forms like painting, is symptomatic of a failure on the part of those who control these institutions to grapple fully with all the art that is actually being made today. Heavily invested in the myth of an avant-garde, built on a model of endless breakthroughs, a rich and fertile medium like painting is foolishly disregarded.

Because an increasingly significant portion of what is made by contemporary artists is fabricated by contracted craftsmen, or on computers, the respect for the well-made object that incorporates its making into significant aspects of its meaning, has somehow become discredited. The result has been that the artist's hand is considered less important than the artist's ideas—ideas mind you; not complex thought expressed visually, but simple-minded ideas that are commonly considered in the art world to be more substantial than they really are. Because they are presented in the context of serious art, they are assumed to carry serious meaning. I know I cannot argue with its inclusion in the category of visual art, but Sherrie Levine's photo of a Walker Evans photo is an expression of a very small idea. It has not even added very much to the Duchampian principle it is meant to address. Painting as an art form of tactile vibrancy goes on in artist's studios, but remains largely ignored, which stifles the contribution dialogue has traditionally made toward painting's development. The

narrow view taken by leading institutions has once again made the mistake of giving into academic persuasion. I am not so quixotic to expect there can be a revival of painting's pre-eminent status. Our times are what they are, and electronic and digital media will inevitably account for a sizable part of what artists offer to the public. But the innumerable classes and species of painting remain vital, and deserve to be seen and discussed in a public forum.

Art is an unfinished business that began more or less when a tiny minority of nomadic cave dwellers felt compelled to scrawl animal images onto damp stone by torchlight. And just as their more practical minded detractors probably sidled back into the cave when no one was looking, to take a furtive glance at those strange yet familiar images, an audience of viewers has always played a part in that particular sort of human exchange that art makes possible. My work became a struggle with the question of what to paint because I felt the relationship between artist and viewer could only exist in a context of common interest. No matter how strong my intuition pulled me toward an idea, I felt I had to consider its viability in terms of how others might see it.

To be clear, I never made decisions in the studio based on whether viewers might like what I did. I cared only that I was providing enough substance for a viewer to find each finished piece, in its full visual construction, worthy of their consideration. The answer in part seemed to lay in subject matter, with the rest a consideration of what the hand and the eye can render with practice and commitment. Over time I came to believe that subject matter had to be a mutual property. Relying on imagery that was entirely the product of the artist's internal musings, without considering that it could be simply incoherent to a viewer, was to ignore the greater part of the art experience. I came to appreciate that building a painting around a subject that a viewer has likely considered prior to encountering the painting itself, stood a better chance of engaging that viewer in a meaningful way.

During the 1980s Suzi Gablik published a small book called, *Has Modernism Failed?*, that I found invaluable for several reasons. First

because it honestly addressed the issues surrounding an artist's attitude toward their audience, and second because Gablik's commentary was inspired by, and led me to, Lewis Hyde's book, *The Gift*, which I believe is the most important book on the definition of the artist's function in society that I have ever read. Though I was in agreement with Gablik's assessment of the crisis in the art world, I could not sign on to her notion that artists ought to steer their work toward political expression; not that I disagree with her political leanings, or to the viability of adapting the process of art to alternative social purposes. But from what I've seen, art exhibited in galleries is the least effective political tool ever devised. Leon Golub's powerful images of mercenary cruelty and Ai Weiwei's recent video of his dropping an ancient vase, are rare exceptions of contemporary art that managed effective political commentary. I admired the cleverness of Andy Warhol's 1972 *Vote McGovern* poster with a green-faced Nixon, but the fact that McGovern's campaign was such a disaster only fortifies my lack of faith in political art. Though not meant to be so, most political art is self-serving, as it tends to preach safely to the choir. The underlying principle of Gablik's argument, that art must change and adapt to political realities is but one way to confront the meaning of art.

But I agree wholeheartedly with both Gablik and Hyde that artists have a moral obligation to the public. Art requires collaboration between artist and audience, based on a respectful awareness of each other's orientation to the work. In that sense all art is political. But just as in politics, the conversation is always in danger of becoming polarized, which is what art institutions like MoMA have done by promoting the narrow, superficial value of the new. The structure of art is made of individuals, not movements or groups. Art has a viable political structure, available through the internal balance an artist may seek in their work between their personal vision and the public's reception of that vision. A successful balance of these values will inevitably contain the seeds of dialogue.

But it is not an easy balance to reach. When an artist pays too much attention to the viewer the result can lean to sentimentality; if they pay too little attention the result can lean toward affectation. This internal dialogue, what is in effect the model for the larger public conversation, requires that artists face the uncertainty inherent in reaching out to the public. This may seem like a radical idea. But for over two hundred years, artists have given new life to their credibility by choosing to swim against the current. Doing so today may be the only viable aspect of a continuing, pertinent avant-garde, and painting—precisely because of its conventionality—is historically positioned to play a key role in what could be a revitalization of art's public relevance. Painting per se does not make better art. But art worthy of our attention is rare enough, without ranking media into unnecessary hierarchies. Installation art is still rather popular, but has not proven to be superior to painting's still fertile nuance.

Walking recently through MoMA's galleries dedicated to art from the 1980s to the present I could not help but notice how the collection contains work of little visual consideration. Ideas dominate, but not the rich ideas of fiction, cinema, or journalism, but example after example of technical apparatus focused on ideas small enough to fit on a Post-it note. The mystification of the art object has evolved into an apotheosis of technology. Video screens, wires, processes, chemicals, references to media-generated symbols, together dominate the visual array in these galleries. What they hold in common is how each installation seems dedicated to providing evidence that the artist has considered the idea to which the art work is dedicated. I do not question the sincerity of any of these artists. To question anyone's sincerity is simply bad manners. But the deeper feelings these artists may hold, in regard to their subject, do not seem to be expressed in their presentations. Instead, each piece is evidentiary, rather than expressive, and seems designed to illustrate rather than explore the content, which leaves the viewer in receipt of a headline, rather than a column of thoughtful, flexible and interconnected ideas.

In conjunction with a recent exhibition at MoMA of Olafur Eliasson's work there were towers designed by Eliasson, built under the auspices of the Pubic Art Fund at several locations around New York City's extensive waterfront, designed to act as artificial waterfalls that could be appreciated for the beauty we associate with similar natural events. Having seen several my verdict was inconclusive. I liked the unpretentious idea of them. I wanted them to work. But the scale of New York Harbor and its massive bridges had a tendency to dwarf the impact of their otherwise considerable size. Moreover, they were a bit too functional looking, as became clear to me on a commute home during the exhibition.

Driving home along Richmond Terrace, a road that follows the north shore of Staten Island I passed a depository for salt used on the streets during snow storms. The salt was being unloaded via a tall conveyer belt from ship to shore. Working into the evening the laborers had set up a bright lamp focused on the upper edges of the pyramid-like mound of salt as it sat by the Arthur Kill. The salt was falling in a steady stream, similar in scale and motion to Eliasson's waterfalls. Not only did the crystal grains of salt appear luminous, the work light made the salt glitter against the darkening sky as it fell along the sides of the sublimely geometric triangle below. It was not art, but it was so much more impressive visually than the mechanical waterfalls. And it reminded me that the advantage a painter has over an artist who chooses to realize ideas for temporary installations is the ability to change and adapt while working—thousands of times if necessary—in order to create a finished piece worth the time and effort the public is encouraged to invest in it, precisely because it is the product of many interconnected thoughts and reconsiderations, not just a single, modest idea efficiently executed.

Working against trends is exhausting. As I pursued an art of meaning I was challenged in so many ways over the years that if I were given the chance to do it all over again I wonder if my determination would hold up. As this small volume attests, what helped me survive

was a consistent reliance on whatever talent I had; a predilection for mental drifting that stood guard over my imagination; a feeling of confidence out of balance with my abilities at significant moments; and the generous support of teachers, colleagues, family and friends. But most importantly, I could not have grown without the inspiration sparked by an ongoing dialogue with artists, including many long gone, whose work remains in public collections for all to communicate with. Though contemporary art may currently appear subservient to an arbitrary and superficial art market, I am confident this is a temporary situation. The job of an artist is indeed to question the nature of art, but to do so does not demand the rejection of how art's nature had been understood prior to raising the question.

For what it's worth, I hope young artists working today come to realize as they mature that it is possible to be contemporary and relevant, and still practice painting in a manner that relies more on a viewer's deeper experience of life and less on a familiarity with the newest ideas. The discomfort they may feel in taking an approach similar in style to art of the past should never deter them from exercising the freedom that is their cultural inheritance. Only those who consciously attempt to reproduce historical styles, or mimic the superficial mannerisms of the past, are in danger of slouching toward inconsequence.

To be a contemporary artist is indeed to accept the challenges of one's times. We find ourselves these days drowning in images from electronic devices that display or print pictures for momentary, even instantaneous consumption, and it is tempting for any visually sensitive individual to conform to this universe of disposable imagery. An unfortunate edginess seems to be the preferred method for escaping the dominance of this unprecedented cultural banality. I would like to see artists, particularly painters, consider how this situation begs instead for a contemplative visual engagement with the actual, as opposed to the virtual world. Personal interpretation and instinct will inevitably

foster variation and originality, so we as painters should have nothing to fear in examining human existence directly.

Though there were moments in this narrative when a sudden change in my attitude was marked by an epiphany, most of the turns in the road I've travelled have been gradual, gestating in my mind for long periods of time along with other unrelated and often contradictory ideas. Of the many changes that came to me this way, the decision to focus my attention specifically on painting instead of a definition of art inclusive of new media was particularly significant. I no longer remember exactly when it occurred, but at some point in the past decade I decided that an art of endless reinvention had become too unwieldy a burden to struggle with in the studio. For me to match my talents to my work and, frankly, to keep my sanity I decided I would retain the title of painter and leave the rest of the art world to those whose sensibilities seem better suited to deal with the new, and not so new array of media. Painting is not the dominant expression it once was, but for those of us who are born painters there remains a great deal to both celebrate and to improve upon.

For one thing, painting remains as broadly defined as ever. This is both a blessing and a curse as painters face at least as many positive options as there are distractions to mislead them. What I look for in the pursuit of good painting is a sense from the canvas that the painter thinks intelligently and in genuinely visual terms. Among the many good painters working today I particularly admire Lois Dodd, Julian Hatton and Amy Sillman, all of whom are doing extraordinary work in their individual examinations of painting as a vital art form. Each in their own way respects the visual world as we experience it, while articulating their internal vision in fresh, painterly terms.

Like all artists, I would not be the artist I am today were it not for the inspiration I received from hundreds who came before me. If I had to make a list of those currently relevant to me, among the many names that might appear would surely be Édouard Manet, Mary Cassatt, Joaquin Sorolla, Thomas Eakins, Fairfield Porter and Lucien

Freud. As an artist in the broader sense of the term I have learned invaluable lessons from the work of George Trakas, Robert Smithson, Gabriel García Márquez, Samuel Beckett, Gustav Mahler, Stanley Kubrick and Barnett Newman. But again, this is a short version of a much longer list I will not bore you with. Every artist has their own.

I prefer to stand aside the art world's academic infatuation with context, and choose instead to respond to the world as I see it via the medium for which I am apparently best suited. Because this is a position easily misinterpreted as nostalgic, I feel compelled to distance myself from those who speak of the old masters in mawkish, sentimental terms. I have no more inclination to advocate a return to classical tradition (whatever that is) than I do for reviving the medicinal application of leeches. Attempting to turn the clock back is just another example of ideological myopia. I work no differently than any other contemporary artist following their inspiration. But when my inspiration leads me to territory which current theory judges anachronistic, I resist the temptation to lean on irony, or to camouflage my use of older conventions with edgy challenges to taste and human sympathy. I choose to be unembarrassed by my wish to explore the maddeningly difficult medium of paint, and the almost impossible rendering of a convincing figure on a flat surface.

At the moment I'm writing this I feel I can paint portraits until they carry me out in a box. But I know too that something else might come along. I could easily return to landscape, or perhaps take the figure in a different direction. There is no need to identify the possibilities in advance because they will make themselves known. As a professional artist I am obligated only to pay attention to the stream of sensations I was born to recognize, and to continue in my effort to invite each viewer to join in the conversation.

Bibliography

Alighieri, Dante. *The Inferno.* Trans. John Ciardi. New York; Mentor Books, 1954.
Beckett, Samuel. *Ends and Odds.* NY; Grove Press, 1976.
Beckett, Samuel. *Waiting for Godot.* NY; Grove Press, 1954.
Bloom, Harold. *The Anxiety of Influence.* London; Oxford University Press, 1975.
Brookhiser, Richard. *James Madison.* NY; Basic Books, 2011.
Clark, Kenneth. *The Nude.* NY; Doubleday Anchor Books, 1956
Clark, T.J. *Image of the People.* Berkeley; University of California Press, 1973.
Gablik, Suzi. *Has Modernism Failed?* NY; Thames & Hudson, 1985
Gould, Glenn. *The Glenn Gould Reader.* NY; Alfred A. Knopf, 1985.
Greenberg, Clement. *Art and Culture.* Boston, Mass.; Beacon Press, 1965.
Hershfield, Harry. "Interview." *New York Times*, 12/5/1965 pg 87
Hess, Thomas B. *De Kooning: Recent Paintings.* NY; Walker & Co., 1967.
Hyde, Lewis. *The Gift.* NY; Vintage Books, 1983.
Knowlson, James. *Damned to Fame.* NY Simon & Schuster, 1996
Koestler, Arthur. *The Act of Creation.* New York; Macmillan, 1964.
Oakeshott, Michael. *Rationalism in Politics and Other Essays.* NY; Basic Books, 1962.
Ratcliff, Carter. *The Fate of a Gesture.* New York; Farrar Straus & Giroux, 1996.
Rosenquist, James. "Interview". *Linea: Art Students League*, 9-2, Fall 2008.
Roth, Moira. "Smithson on Duchamp: Interview". *Artforum*, October, 1973
Schoenberg, Arnold. *Style and Idea.* Berkeley; University of California Press, 1984.
Stevens, Wallace. *The Collected Poems of Wallace Stevens.* NY; Knopf, 1985.
Sullivan, Louis H. *The Autobiography of an Idea.* 1924. NY; Dover, 1956.
Wills, Garry. Op-Ed, *New York Times.* 9/6/1998.

ABOUT THE AUTHOR

Both a native and lifetime resident of New York City, Peter Malone has exhibited his paintings at the National Academy of Design, NYC; Grace Borgenicht Gallery, NYC; Gallery Henoch, NYC; Pratt Institute, Brooklyn, NY; the Hudson River Museum, Yonkers, NY; the Laguna-Gloria Art Museum, Austin, TX; the Islip Art Museum, Islip, NY; the Munson Williams Proctor Museum of Art, Utica, NY; Moravian College Art Gallery, Bethlehem, PA; William Paterson University Art Gallery, Wayne, NJ; Set Gallery, Brooklyn, NY; the Albany Institute of Arts and Sciences, Albany, NY and the Southern Vermont Arts Center, Manchester, VT. His work is represented in numerous private and public collections across the country. He has authored several catalog essays for exhibitions at the Kingsborough Community College Art Gallery of the City University of New York, where he currently serves as gallery director.

Art work referenced in this book may be viewed at:

www.petermalone.com > click *enter*, then click the *writing* tab

www.ingramcontent.com/pod-product-compliance
Lightning Source LLC
Chambersburg PA
CBHW030749180526
45163CB00003B/951